KILLER PHOTOS WITH YOUR IPHONE®

Matthew Bamberg, Kris Krug, and Greg Ketchum

Course Technology PTR

A part of Cengage Learning

COURSE TECHNOLOGY
CENGAGE Learning™

Australia, Brazil, Japan, Korea, Mexico, Singapore, Spain, United Kingdom, United States

COURSE TECHNOLOGY
CENGAGE Learning™

Killer Photos with Your iPhone®
Matthew Bamberg, Kris Krug, and
Greg Ketchum

**Publisher and General Manager,
Course Technology PTR:**
Stacy L. Hiquet

Associate Director of Marketing:
Sarah Panella

Manager of Editorial Services:
Heather Talbot

Marketing Manager:
Jordan Castellani

Executive Editor:
Kevin Harreld

Project Editor/Copy Editor:
Cathleen D. Small

Technical Reviewer:
Cathleen D. Small

Interior Layout:
Jill Flores

Cover Designer:
Mike Tanamachi

Indexer:
Sharon Hilgenberg

Proofreader:
Sue Boshers

For product information and technology assistance, contact us at
Cengage Learning Customer & Sales Support, 1-800-354-9706

For permission to use material from this text or product, submit all requests online at **cengage.com/permissions**. Further permissions questions can be e-mailed to
permissionrequest@cengage.com.

iPhone is a registered trademark of Apple Inc., registered in the U.S. and other countries. All other trademarks are the property of their respective owners.

All images © Cengage Learning unless otherwise noted.

Library of Congress Control Number: 2010922095

ISBN-13: 978-1-4354-5689-1

ISBN-10: 1-4354-5689-0

Course Technology, a part of Cengage Learning
20 Channel Center Street
Boston, MA 02210
USA

Cengage Learning is a leading provider of customized learning solutions with office locations around the globe, including Singapore, the United Kingdom, Australia, Mexico, Brazil, and Japan. Locate your local office at: **international.cengage.com/region**.

Cengage Learning products are represented in Canada by Nelson Education, Ltd.

For your lifelong learning solutions, visit **courseptr.com**.

Visit our corporate Web site at **cengage.com**.

Printed in the United States of America
1 2 3 4 5 6 7 12 11 10

*To all the software developers who
create apps for the iPhone camera*

Acknowledgments

No iPhoneography book can be written without describing the apps that make the iPhone camera so wonderful. A special thanks goes out to the developers of those apps. The authors would also like to thank Kevin Harreld for accepting the proposal for this book and believing that three authors could come together to put together such a book. They would also like to extend kindest regards and thanks to Carole Jelen, the literary agent who not only brought the three authors together, but who also helped design the concept of the book. Last but not least, special thanks goes to Cathleen Small, whose knowledge of the iPhone comes firsthand and whose editorial skills are second to none. Finally, the authors would like to thank Danielle Sipple, who did a wonderful job gathering photos for this project.

About the Authors

Matthew Bamberg is the author of many books about digital photography. He is a Professor of Education at National University and currently teaches the History of Fine Art Photography at UCR.

Matthew began his career in the arts as a graduate student at San Francisco State University in 1992. His work in the visual and media arts included video production and software applications. He completed his master's degree in Creative Arts in 1997.

Matthew's experience with cameras goes back to 1998, when he started shooting from different locations around the world. He began selling his photographs first at consignment stores and then at galleries and other retail venues in Southern California. His catalog of photography consists of thousands of photographs from his travels in Myanmar, Cambodia, Vietnam, Argentina, Uruguay, Canada, Morocco, Russia, the Baltic states, and countries throughout Europe.

As a public-school teacher for 14 years, Matthew spoke at many educational technology conferences. His work became well known throughout California after he secured a state technology grant. After teaching school, Matthew became a writer and professor. He began to photograph for the articles he was writing while working for the *Desert Sun* and *Palm Springs Life* magazine in the Palm Springs area of California. In 2005, Matthew's book, *Digital Art Photography for Dummies*, was published.

In 2008, Matthew authored *The 50 Greatest Photo Opportunities in San Francisco*. In 2009, he completed the *101 Quick and Easy* photography book series. *101 Quick and Easy Secrets to Create Winning Photographs* was published in April 2009, *101 Quick and Easy Secrets for Using Your Digital Photographs* was published in September 2009, and *101 Quick and Easy Ideas Taken from the Master Photographers of the Twentieth Century* was published December 2009.

Kris Krug is a fashion, music, and portrait photographer, a technologist, and an author based in Vancouver, BC, Canada. He is owner Static Photography, a photography studio in Vancouver, BC. He is also a teacher and consultant for new media and the Internet. Krug brands himself as a techartist, quasi-sage, cyberpunk anti-hero from the future. For three years, he was the editor-in-chief of the online magazine *spark, a culture and technology monthly with a philosophical bent. He was the coauthor of *BitTorrent for Dummies* (Wiley, 2005) As a photographer, his photos have been published in *National Geographic*, *Rolling Stone*, *Business Week*, *Financial Times*, *USA Today*, *LA Times*, PBS, and many other online and print publications.

Constantly challenging himself by shooting diverse subjects, from emerging rock bands to dot-com execs, Kris uses his engaging personality to break down the barriers between lens and subject. He treats each person with a gentle hand, allowing subjects to comfortably express themselves. Combined with a calculating eye (and a penchant for cross-processing), the result is a capture of people's truest essence—a story of their life in tableau as unabashed artistic documentation, whether the subject is a man out in front of his downtown East Side apartment, a fashion model, or a farmer in the back hills of China.

Kris is a fervent evangelist for open culture and creative commons licensing and frequently speaks at conferences and in the media about the blurring lines between pro and amateur, shifting copyright standards, and using technology to promote and share artistic work. Kris realizes art isn't created in a vacuum and a vibrant community is key for culture to flourish. With this in mind, he organizes photo walks and workshops for newbies and veterans alike to encourage knowledge sharing and collaboration.

Dubbed the "Frasier of the Cubicles" by the *San Francisco Chronicle*, **Dr. Greg Ketchum** is a former clinical psychologist turned CEO and media workplace and executive coach. He presides over an executive talent firm, providing coaching for executives and Fortune 500 companies. A unique mix of psychology and coaching expertise gives Dr. Greg a great understanding of people and what it takes for career success. Combined with his keen insight into today's workplace and infused with his trademark quick wit, Dr. Greg challenges his clients to reach for career success on their own terms—and to have a good time doing it.

Dr. Greg's interest in photography stretches back to his days as a boy taking pictures on his bicycle with his Kodak Brownie Instamatic. He has always loved the visual arts, including photography, cinematography, painting, and architecture. When he was a teenager, he built his own darkroom in the family garage and began developing and printing his own black-and-white photographs. In college, he was a photography major before moving on to psychology; but despite that move, Dr. Greg always has had his camera nearby. Having children opened up an entirely new world of photography for him as he spent many hours taking pictures of his children.

He loves working with film in the 35mm format and only reluctantly moved into the world of digital photography, but once he made the move, he began to see the amazing photographs that could be created in the digital format. With the introduction of the iPhone and photography applications for it, Dr. Greg's creativity has been unleashed in a way that was not possible working only with film. He loves the idea that having his iPhone and photography applications is like having a virtual darkroom in his pocket. Although he has been a photographer his entire life, this is his first book of photography.

Dr. Greg created the Coach-on-Demand Series Podcasts®, which are a revolutionary new way for companies to provide highly targeted self-directed learning and development modules for their employees. His podcasts make the expertise of an executive coach available to all employees in a cost-effective manner and provide just enough coaching expertise just in time to enable employees to overcome any pressing workplace challenge. The podcasts average 10 minutes in length, are highly portable, and are based on actual workplace situations.

He received his B.A. from the University of California, Berkeley, where he was Phi Beta Kappa and a Dean's List Scholar. He received his M.A. from the University of California, Santa Barbara and his Ph.D. from California School of Professional Psychology, Berkeley. During his graduate studies, he was awarded a California State Fellowship.

In addition to his work as a management consultant, he has served on the faculty of the University of California at Berkeley Extension. Dr. Greg has four children and lives in Muir Beach, California.

Contents

CHAPTER 1
iPhone Overview ..3
Locking and Turning On/Off..4
iPhone Camera Parts ..5
iPhone Photo Resolutions ..6
iPhone Camera Specs and Settings10
Changing Image Sizes ..17
Transferring Photos ..17
Synching Your Phone ..24
Getting or Buying Apps ..25

CHAPTER 2
Using the iPhone Camera31
Taking a Picture ..32
Viewing Photos ..34
iPhone 3G Fixed Focus ..35
iPhone 3GS Tap Focus ..36
iPhone Macro ..39
Holding the Camera for a Sharp Shot40
Working without a Zoom Lens42

CHAPTER 3
Better Photos on an iPhone45
Lighting for Sharp Photos ..46
Closing In on Objects ..48
Adding Bright Colors to the Frame50
Using the Rule of Thirds to Frame Photos55
Trying a Worm's-Eye View ..59

CHAPTER 4
Portraits ...61
Ready for Your Close-Up? ..62
Have Your Subject Do Something...62
Shooting a Person inside a Vehicle...63
Simplifying Your Background ..65
Positioning Your Subject ...66
Creating Interesting Backgrounds ...71
Positioning Groups of Two and Three72
Having Subjects Interact ...74
Shooting at an Angle..77
Photographing Body Parts..80

CHAPTER 5
Photographing Places and Things85
Working with Flowers...86
Photographing Architecture ..90
Photographing Landscapes...100
Photography as Art ..107
Street Photography...109

CHAPTER 6
Working with Different Types of Light115
Reflective Light...116
Direct and Indirect Light ...118
Night Photography ..123

CHAPTER 7
All About Applications ...129
Downloading and Installing Apps from Your iPhone......................130
The Photography Section of the iPhone App Store on Your iPhone131

CHAPTER **8**
Resizing, Cropping, Framing, and Printing Photos**143**

Resizing on the iPhone...144
Cropping and Rotating on the iPhone ...146
Printing Photos ...157
Framing Photos..157

CHAPTER **9**
Post-Processing Apps: Tweaking Photos after the Fact in PS Mobile, Brushes, and CameraBag...**165**

Free and Easy PS Mobile...166
Paint Your Way to Fame with Brushes ..169
CameraBag Belts Out the Filters ..180

CHAPTER **10**
Post-Processing Apps: Tweaking Photos after the Fact in PhotoForge, ColorSplash, FX Photo Studio, and Photo fx.........**195**

PhotoForge ...196
ColorSplash ..212
FX Photo Studio ...218
Photo fx ..227

CHAPTER **11**
Sharing Your Killer Photos ..**245**

Sharing via Apps ..246
Sharing on Flickr..247
Sharing Using Photobucket..250

Index..**252**

Introduction

The iPhone camera has become a novelty since its inception a few years ago. There is so much that you can do with the camera, from taking simple pictures to using the apps available for it to create new and innovative photographs, that one of the reasons why people are buying iPhones is to have the camera and apps that go with it.

The iPhone camera can easily be with you all the time, and it's a unique device that lets you take and process photos just by touching a screen. This book covers it all—from taking the picture with or without the many apps that can assist you with, say, a timer and/or image stabilization, to post-processing the images with hundreds of options using a variety of apps that can turn an ordinary photo into a work of art.

There's a new field of photography—iPhone photography, or *iPhoneography*—that has made its way onto the general photography scene the past few years. Photos taken with an iPhone are so unique and compelling that millions of people have taken to the medium, snapping and processing pictures by tapping and swiping the iPhone's small screen on which the images appear.

Several Flickr photo groups have tens of thousands of members and photographs taken with the iPhone. Many have been tweaked with one or more of the dozens of apps available for the device. Three of the largest are www.flickr.com/groups/takenwithiphone, www.flickr.com/groups/iphoneography, and www.flickr.com/groups/ifone. There's even an *iPhoneography* magazine.

Once you delve into this book, you'll find everything you need to know about the iPhone camera and the apps that go with it. If you're an iPhone photography newbie, the basics of shooting with the iPhone are covered in detail. You'll find out how to aim, compose, and focus your shots with both the 3G and 3GS models. The book goes on to cover shooting within the platform of an app and then post-processing using an app. Using specific apps such as PS Mobile, PhotoForge, and ColorSplash is described option by option, so you can learn every aspect of what the app can do. This is especially helpful because when you're viewing an app's features, you can only do so on a piecemeal basis. With this book, you'll see everything the app does clearly, without having to take several minutes or longer to tap around to find out what options are available.

Once you get used to surfing an app, using others like it gets easier.

Note that the book covers the version of each app that was available at the time of writing. New, updated versions of the apps are released from time to time. (The book tells you step by step how to identify and update these versions.) Although the directions in the book for using the apps might describe an older version, the versions are usually pretty much the same, except that the software writers often add more options to the app. They don't usually change the way the app runs, so you can use the descriptions of the apps written for this book to learn how to use most of the new, updated versions of the apps.

The most important thing you can do with this book is to have a great time making your photos better by using both traditional techniques and techniques that are offered by the wonderful apps available for the device.

—Matt Bamberg

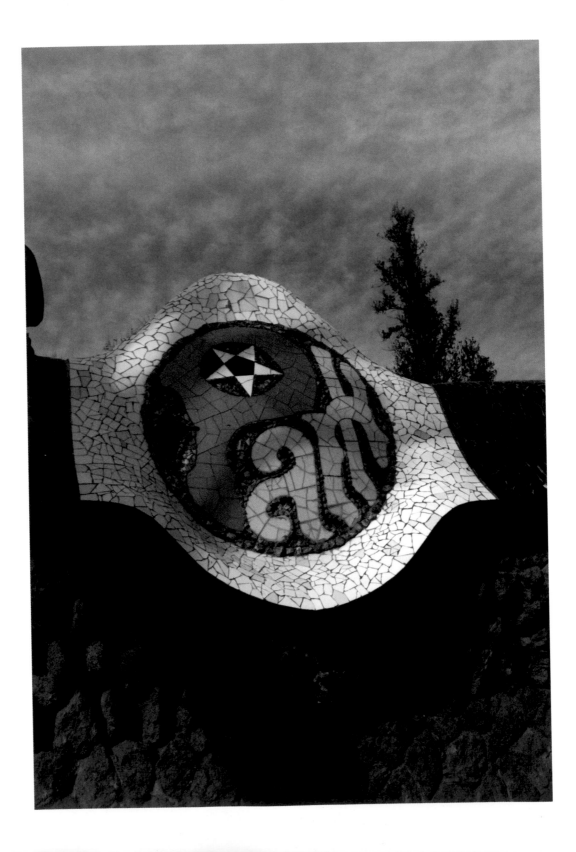

CHAPTER 1
iPhone Overview

Your dream has finally come true: You've got a new iPhone (or you've had one for a while), and you're ready to use the camera to take killer photos in what has become a new kind of contemporary art—the iPhone photo.

This chapter starts at the very beginning, with turning the phone on and off. Beyond that section is the brave new world of the iPhone camera. Don't miss a bit, because everything there will help you not only to take killer photos, but also to learn all there is to know about getting your iPhone photos from one place (such as your iPhone) to another (such as your computer). It also covers how to buy those great apps and install them on your iPhone, so you can use them with the help of this book. Using the apps is discussed in a later chapter.

Locking and Turning On/Off

The iPhone comes with easy-to-use buttons and a touch-screen interface that takes no time to learn to operate.

As soon as you get your iPhone home, you'll want to turn it on. To do so, you hold down the Sleep/Wake button (the button on the top right of the phone) until you see the white apple on the screen.

After a few seconds, the screen will change to show a big picture of the Earth with the current local time on top and a message that reads Slide to Unlock, as shown in Figure 1.1.

Figure 1.1 The iPhone needs to be unlocked to operate.

N O T E

If you don't interact with the phone for several seconds, the screen will go blank. It will be in Sleep mode. To get it back, press the button on the top of the phone again or hit the big button in the bottom center of the phone (the Home button).

Using your index finger, touch the screen at the right-pointing arrow and move your finger horizontally across the text that reads Slide to Unlock.

N O T E

Each time you wake up your iPhone from Sleep mode, you'll have to unlock it again.

To shut down your iPhone, press and hold the button on the top of the phone for a few seconds.

iPhone Camera Parts

After you've unlocked your phone, you'll be taken to the home screen, where there is a list of applications that are available to you. One of those applications is the camera, and another is for your photos. You can see the Camera and Photos icons in the first row of icons in Figure 1.2. These two applications are standard with all iPhones.

The iPhone 3G and iPhone 3GS have internal flash drives with the following capacities:

- iPhone 3G: 16 GB
- iPhone 3GS: 16 GB or 32 GB

Without anything else in the 16-GB internal flash drive, an iPhone 3GS can hold about 1,500 images. The 32-GB iPhone 3GS can hold about 3,000 Images. Since the files of the 3G are smaller, its 16-GB internal flash drive can hold more photos than that of the 3GS—more than 2,000.

The iPhone 3G has a fixed-focus 2-MP camera. The iPhone 3GS has an auto-focus 3-MP camera with touch-screen focus.

To use the touch-screen focus, all you do is frame your shot and then touch the screen on the subject/object on which you want to focus. There are different effects you can achieve using this built-in app. (To learn what effects you can get, see Chapter 2, "Using the iPhone Camera.")

Figure 1.2 Tap Photos to see your photo albums or touch Camera to be brought to the camera interface.

The lens on both types of iPhone is located on the back (the white or black part, depending on the phone) on the left side as you're looking at the back of the phone.

iPhone Photo Resolutions

There are two different kinds of iPhones: the iPhone 3G and the iPhone 3GS. The former comes with a 2-MP camera, and the latter with a 3-MP camera. Although that might not seem like much, the technology of the iPhone is so fine-tuned that you get pretty good image quality at these low resolutions.

The image size for a 2-MP photo is 1200×1600 pixels, or 16.667×22.222 inches at 72 dpi. This size photo is more than adequate for publishing your iPhone photos on the web. They'll remain sharp even when they appear large on a website. If you want to consider blowing up your images, you have to look at print resolutions that are about 300 dpi. At 300 dpi, 2-MP iPhone images are 4×5.333, which means you can print that size photo and get sharp results. Probably the biggest photo size to which you could blow up an iPhone photo from a 2-MP camera is 6×8 inches. Anything bigger than that, and you'll find yourself with a print that contains pixelization, or tiny colored dots all over the image.

Another way to examine the image you get from an iPhone is to look at it on your computer screen. When a photo is open on your computer screen, you usually view it at a size smaller than its actual size. To see exactly what's going on with your photo in terms of sharpness, you have to view it at 100-percent resolution on your computer screen. To do this in Photoshop or Elements, you just type in 100 for the value in the box in the lower-left part of the window in which the image is displayed. Figure 1.3 shows how you'll see an image taken with a 2-MP iPhone camera on your computer screen. The image looks incredibly sharp—much sharper than images taken with other types of cell-phone cameras. Blow up that same image to 100-percent resolution, and you'll begin to see pixelization like that which shows up in the hair of the model in Figure 1.4. However, there is only a small amount of sharpness lost at full resolution (100 percent).

Figure 1.3 A 2-MP image as seen on a computer screen at 50-percent resolution.

Figure 1.4 A 2-MP image as seen on a computer screen at 100-percent resolution.

NOTE

When pixelization appears in an image, you'll see tiny colored dots that make up the contents of the frame.

You can see the various sizes of iPhone files in Table 1.1. The image size for a 3-MP file is 2048×1536 pixels, or 28.444×21.333 inches at 72 dpi. Just as the images from the 2-MP model are perfectly good for publishing your images to the web, so are those from a 3-MP camera. At 300 dpi, 3-MP iPhone images are 5.12×6.83 inches. In Figures 1.5 and 1.6, the images are relatively sharp with little pixelization. The image at 100-percent resolution has less pixelization than the image in Figure 1.4.

Figure 1.5 A 3-MP image as seen on a computer screen at 50-percent resolution.

Figure 1.6 A 3-MP image as seen on a computer screen at 100-percent resolution.

Table 1.1 iPhone Resolutions and File Sizes

iPhone Type	File Size	Dimensions	Size at 72 dpi	Size at 300 dpi
iPhone 3G	400–700 KB	1200×1600 pixels	16.667×22.222 inches	4×5.333 inches
iPhone 3GS	1–2 MB	2048×1536 pixels	28.444×21.333 inches	5.12×6.83 inches

iPhone Camera Specs and Settings

There are several variables at play when you take a picture with an iPhone. As you look at these specs and settings, you'll find that the iPhone is in a league of its own. The camera's sensor, aperture, shutter speeds, ISO speeds, and focal lengths work in the same way as they do on any camera in that there are specified values/measurements for each. It's just that with an iPhone, some of these values remain constant, whereas others constantly and automatically change according to what the camera sees through its lens.

As you would probably expect, the sensor of the iPhone camera is very small. It is only 0.25 inch wide. That would be about 6.35mm. When you consider that a strip of negative film and the sensor of a full-frame camera is 35mm, you roughly have one-sixth the space of the full-frame sensor to imprint the image. You'd think that this sensor size combined with a reduced number of megapixels could not produce a good picture with an iPhone camera. For many images this is true if you consider the images in terms of traditional photography.

iPhone specs at a glance:

- An iPhone 3G sensor is 0.25 inch CMOS.
- An iPhone 3GS sensor is 0.25 inch CMOS.
- The iPhone 3GS has a focal length of 3.9mm, which is 28mm (35mm equivalent).
- iPhone aperture is f/2.8.

THE TIMES, THEY ARE A-CHANGIN'

Digital photography is changing. Although the images you get with an iPhone camera might not be high quality in terms of sharpness, the results you get are sometimes so unusual and captivating that the images are an art form in and of themselves. With the number of point-and-shoot cameras and camera phones out today, there is a whole new branch of photography developing.

Kris Krug and Greg Ketchum, the coauthors of this book, are changing the way people look at this new photography.

Kris points to the false notion that you have to have a dSLR to take a great photograph. "You know, all of my friends come to me asking what the best camera is to buy and should they get a dSLR or not," he says. "I am not discrediting the dSLR, because really, it is a great camera, but sometimes people think that in order to take pictures, they have to have the most expensive, best, and biggest camera, which really isn't the truth."

He emphasizes the need for a camera that you'll actually use. "My advice to my friends during all of this is for them to think more about compact cameras, because if a camera is compact, it tends to more accessible and portable," he explains. "Really, at the end of the day, you want a camera that you are going to take the most photos with, and if that means a compact camera like on your phone, then that is the best camera for you."

Greg has pretty much the same opinion about the iPhone camera, but a different personal story. "I have a beautiful 35mm Nikon camera and a small Canon digital camera that I used for several years," he begins. "Ever since I've had my iPhone, that little Canon has been on the shelf gathering dust along with my Nikon."

He, too, had the feelings of a photo purist. "The photo purist in me has always believed that you can only get great shots with super-expensive equipment that, of course, has to have manual overrides to the automatic settings."

(continued)

Figure 1.7 Image taken with an iPhone and manipulated with iPhoto.

THE TIMES, THEY ARE A-CHANGIN' (continued)

His purist position has changed because having the camera phone is easy: "I can't tell you how many times I've been out walking or driving somewhere and seen that beautiful shot that I'd love to take if only I had brought my camera with me," he explains. "It feels great to finally be able to stop kicking myself for all the gorgeous shots that I missed because I didn't have a camera in hand."

Not only is the camera easy to carry around, there are also hundreds of apps you can use to make your images into real art, and it's easy to get your pictures anywhere you want right away.

Figure 1.8 Kris used the Infared camera setting on the CameraBag app in this photo.

Kris finds that the amazing thing about using the camera on your phone is that technology has advanced so much that you not only have a camera in your hand, but you also have an editing program and an uploading program. "You can literally take a photograph, edit in one of the dozens of available editing applications for the iPhone, and then upload to the Internet in a matter of two minutes," he explains. "What used to take hours now is instantaneous and literally can be done on the go, wherever a connection to the Internet is available."

So what does the iPhone use for an aperture and shutter speed setting? You can find this out in the image capture program when you download your photographs from your camera to your computer. (See the "Transferring Photos" section later in this chapter.) Both the iPhone 3G and the 3GS shoot with a wide aperture of f/2.8.

The iPhone 3G has a fixed focus point, which means it will focus at a point in the middle of the frame. (For more about shooting with the fixed focus and the tap focus of the 3GS, see Chapter 2.)

The iPhone 3GS has a Tap to Focus feature, which means you can have the lens focus on any point you tap on the screen. It also exposes the photo using the light available from that point, which brings up a host of capabilities in terms of how bright or dark your photo is. (See Chapter 3, "Better Photos on an iPhone.")

The iPhone 3GS shoots in Aperture Priority mode.

NOTE

Aperture Priority mode is when the camera uses a set aperture (lens opening) to take a shot and decides, based upon the light available, how long to open the shutter for (shutter speed).

The iPhone automatically determines a shutter speed and an ISO speed according to the light available in the shot at a fixed aperture of f/2.8. This makes a big determination in the results you get when you shoot in different lighting conditions.

You can easily determine the ISO speed of shots taken with the iPhone 3GS in Photoshop's Bridge or when you download your pictures in Image Capture (on a Mac) onto your computer. If you're using a PC, Windows will automatically detect your iPhone, and you can access your photo properties with a simple right-click. (See the "Transferring Photos" section later in the chapter.)

If you take a look at some of the shutter speeds and ISO values for different images, you can get an idea of what shutter speeds and ISO speeds work best for an image.

Figure 1.9 1/320 second, ISO 70.

Figure 1.10 1/15 second, ISO 481.

Figure 1.11 1/10 second, ISO 589.

Figure 1.12 1/10 second, ISO 1016.

Take a look at the images in Figures 1.9 through 1.12 and the settings that the iPhone 3GS automatically set the camera to when they were shot.

Figure 1.9 shows that photos can be very sharp. This is because the iPhone uses very low ISO speeds when there is adequate, even light. Figure 1.10, a close-up shot of a ceramic sculpture, shows that the iPhone 3GS does fairly well in terms of sharpness and reduced noise at medium ISO speeds. Figure 1.11 shows that at high ISO speeds (over 500), shots from a distance (long shots) result in blown highlights, softness, and noise indoors, which can be interesting effects. Finally, Figure 1.12 shows the poor results of a shot at a high shutter speed (over 1016, the highest it goes). For more information about ISO speeds, see the "Getting the Lowest ISO Speeds Should be Your Primary Goal When Shooting" sidebar in Chapter 2.

Even though there's no way to get camera settings for the iPhone 3G, you get similar results in terms of shooting in different light situations to what you get with the iPhone 3GS.

In Figure 1.13, you can tell the camera shot at a high ISO speed, because the picture contains some noise. (See the bottom of the image.) When there is little light available, the iPhone will compensate by shooting at very high ISO speeds, resulting in a fairly sharp shot but with a lot of noise (see Figure 1.14).

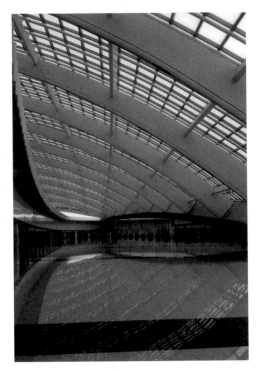

Figure 1.13 Light is muted.

Figure 1.14 Almost no light.

Changing Image Sizes

One thing is for sure: Image size affects the look of your photograph. For Internet purposes, you'll want to resize your iPhone image to send it to others, to display on a website, to use it to sell something on eBay, to upload it via a social networking site, and/or to use it on a blog.

You can change image sizes directly on your iPhone using an app. One app for this purpose is Resizer.

You can also use almost any image processing program on your computer to change the size of your image. When you change your image size, make sure you don't write over it by saving it with the same file name. Always rename the file so the original high-res image stays intact.

The original sizes of your iPhone 3G photos are 9×6.5 at 177.8 pixels/inch, and those for the 3GS are 9×6.5 at 227.5. A good size to reduce the image size for the Internet to is 9×6.5 at 72 pixels/inch, or 648×486 pixels. This should reduce the file size of your image to about 100 KB.

Transferring Photos

You can transfer your photos from your *iPhone to your computer* or from *your computer to your iPhone* by following some simple steps.

To get your images from your iPhone to your computer on a Mac, follow these steps. (The steps for Windows are given after those for the Mac.)

1. Insert the USB cable from your iPhone into your computer.
2. A prompt will come up like that shown in Figure 1.15. (This will come up if your computer is configured to automatically download images using Image Capture.)

Figure 1.15 Choose where you want to download your photos.

3. If you want your photos to go to a folder other than your Pictures folder, use the Download To drop-down menu to navigate to it.

4. In the next window, navigate to the folder in which you want to put your pictures.

5. If you want to delete the photos from your camera after downloading them, click on the Options button. In the window that appears, click on Delete Items from Camera after Downloading. You can also choose options to Create Custom Icons, Add Item Info to File Finder Comments, or Embed ColorSync profile. Finally, you have the Connection Options, which is set to Automatically Download All Items.

6. If you click Download Some, you'll see your images come up in a window like the one shown in Figure 1.16.

Figure 1.16 You can download specific photos that you want without having to download them all.

7. If you want to download one photo, just click on it. If you want to download a group of consecutive photos, hold the Shift key down while you click on the first image and keep it held down while you click on the last photo of the group that you want. If you want to download photos that are not consecutive, just hold down the Command key while you are clicking on them.

8. If you want to see the camera settings and file sizes of your images on a Mac, all you do is click on the Lines icon at the top of the window (next to the Squares or Thumbnails icon) in Figure 1.16. The screen will switch to that shown in Figure 1.17.

Name	Date	File Size	Aperture	Depth	Color Space	Pixel Size	DPI	EXIF	Focal	Shutter	Flash	ISO
IMG_0079.JPG	11/4/09 1:46 PM	1.1 MB	f/2.8	8	sRGB	2048 x 1536	72	2.2.1	4mm	1/321	Off	ISO70
IMG_0080.JPG	11/4/09 1:46 PM	1.1 MB	f/2.8	8	sRGB	2048 x 1536	72	2.2.1	4mm	1/321	Off	ISO70
IMG_0081.JPG	11/4/09 5:03 PM	1.0 MB	f/2.8	8	sRGB	2048 x 1536	72	2.2.1	4mm	1/176	Off	ISO70
IMG_0082.JPG	11/4/09 5:03 PM	982.1 KB	f/2.8	8	sRGB	2048 x 1536	72	2.2.1	4mm	1/264	Off	ISO70
IMG_0083.JPG	11/4/09 5:03 PM	923.7 KB	f/2.8	8	sRGB	2048 x 1536	72	2.2.1	4mm	1/248	Off	ISO70
IMG_0084.JPG	11/4/09 5:04 PM	1.2 MB	f/2.8	8	sRGB	2048 x 1536	72	2.2.1	4mm	1/60	Off	ISO100
IMG_0085.JPG	11/4/09 5:05 PM	1.1 MB	f/2.8	8	sRGB	2048 x 1536	72	2.2.1	4mm	1/120	Off	ISO117
IMG_0086.JPG	11/4/09 5:05 PM	1020.8 K	f/2.8	8	sRGB	2048 x 1536	72	2.2.1	4mm	1/120	Off	ISO105
IMG_0087.JPG	11/4/09 5:05 PM	949.8 KB	f/2.8	8	sRGB	2048 x 1536	72	2.2.1	4mm	1/158	Off	ISO70
IMG_0088.JPG	11/4/09 5:06 PM	989.2 KB	f/2.8	8	sRGB	2048 x 1536	72	2.2.1	4mm	1/206	Off	ISO70
IMG_0089.JPG	11/4/09 5:06 PM	958.3 KB	f/2.8	8	sRGB	2048 x 1536	72	2.2.1	4mm	1/140	Off	ISO70
IMG_0090.JPG	11/4/09 5:06 PM	948.8 KB	f/2.8	8	sRGB	2048 x 1536	72	2.2.1	4mm	1/120	Off	ISO77
IMG_0091.JPG	11/4/09 5:07 PM	986.3 KB	f/2.8	8	sRGB	2048 x 1536	72	2.2.1	4mm	1/60	Off	ISO102
IMG_0092.JPG	11/4/09 5:07 PM	1017.6 K	f/2.8	8	sRGB	2048 x 1536	72	2.2.1	4mm	1/120	Off	ISO98
IMG_0093.JPG	11/4/09 6:47 PM	1.3 MB	f/2.8	8	sRGB	2048 x 1536	72	2.2.1	4mm	1/15	Off	ISO402
IMG_0094.JPG	11/4/09 6:47 PM	1.2 MB	f/2.8	8	sRGB	2048 x 1536	72	2.2.1	4mm	1/10	Off	ISO1,016
IMG_0096.JPG	11/6/09 9:17 AM	1.3 MB	f/2.8	8	sRGB	2048 x 1536	72	2.2.1	4mm	1/610	Off	ISO70
IMG_0097.JPG	11/6/09 9:17 AM	1.1 MB	f/2.8	8	sRGB	2048 x 1536	72	2.2.1	4mm	1/290	Off	ISO70

Figure 1.17 You can view the camera settings and file sizes in the Image Capture program on a Mac.

NOTE

Depending on how you have your computer configured, the program that manages your photo downloads may be different than the one described a moment ago. It may be iPhoto or some other program that manages your computer downloads. If so, the process is similar to the one described here.

If you're working in Windows, the system will automatically detect your iPhone after you connect it using your USB cord.

A window will appear, giving you the following three options: Import Pictures, Open Device to View Files, and Microsoft Office Document Scanning. The first two options are the important ones.

If you click on Open Device to View Files, you can view them without downloading them. To access the images in the window that comes up (see Figure 1.18), all you do is click on one of the folders in the left frame in the window. You can save them one at a time by right-clicking on each image and clicking on Open in the drop-down menu that appears. The image will be displayed in the Windows Photo Gallery. To save it, click on Copy to Gallery in the list of menu items at the top of the window (see Figure 1.19). The image will be copied into the Windows Photo Gallery. To view the file size and camera settings, navigate to File > Properties. In the pop-up window that appears (see Figure 1.19), you'll see the information.

Figure 1.18 In Windows, you can view the images without downloading them.

Figure 1.19 You can save your images one at a time as well as view the image's properties in Windows Photo Gallery.

If you click on Import Pictures, Windows will import them from your iPhone into a new folder (with the date you download as the name) inside of your Pictures folder. The first thing it will ask you is to tag them. You can skip that step (if you want) and just go ahead and click on the Import button. Your photos will then be imported, but be warned that the downloading is slow.

To get your images from *your computer to your iPhone*, follow these steps:

1. Connect your computer to your iPhone using the cable provided with your iPhone.
2. Open iTunes.
3. Drag the folder you want to copy onto the iPhone to your Pictures folder.
4. In iTunes, navigate to File > Sync *your name*'s iPhone.
5. In iTunes, click on your phone's name under where it says Devices.
6. Click on the Photos tab in the iTunes window that comes up.
7. In the Photos tab, there is a check box for Sync Photos—click on it. Then navigate to your Pictures folder. Do not click on the Include Videos option that comes after it. The folders you have in your Pictures folder will be listed under Folders (see Figure 1.20).

Click on any of those that you want to transfer to your iPhone. Then click on Apply. If you want to remove any of those folders of photos, click on the check box next to Synch Photos From. You'll get a message asking whether you want to remove photos previously copied to your iPhone. Click on Remove Photos. Then click on Apply (Synch in Windows). The photos will be removed.

Figure 1.20 You can move a folder of images from the Pictures folder on your computer to your iPhone.

NOTE

If you're transferring images from your computer to your iPhone via a USB cable, the iPhone will automatically downsize your photo to a very low resolution (5×6.667 at 72 dpi). If you want to move a photo at high resolution from your computer to your iPhone, you need to email it to yourself from your computer and then access and download it from an email on your iPhone. To do this, you just tap the photo after it appears on the iPhone screen and follow the saving prompts.

RESIZING PHOTOS FOR COMPUTER-TO-iPHONE TRANSFER

At some point in your work with iPhone photos, you'll want to make a picture you have on your computer smaller so you can transfer it to your iPhone to manipulate it with the many apps iPhones have to offer.

A good size to make a picture for the Internet is from 50 to 150 KB (as a JPEG file). The Internet only handles JPEG, GIF, and PNG files; most of the time, JPEGs are the name of the game for uploading files to websites. If you're going to email high-resolution photos, make them about 1 MB to 3 MB.

For the purposes of this book, we'll work in inches when thinking about resizing a photo. To resize in Photoshop, you navigate to Image > Image Size. (If you're working in Photoshop Elements, you navigate to File > Resize > Image Size.)

The most important box to check or uncheck in this dialog box is Resample Image (see Figure 1.21). When Resample Image isn't checked, you can change the values of Width, Height, or Resolution, and Photoshop/Elements will proportion the photo accordingly without changing the file size (the number you see right next to where it says Pixel Dimensions at the top of the box).

Figure 1.21 You can resize an image using this dialog box.

(continued)

RESIZING PHOTOS FOR COMPUTER-TO-iPHONE TRANSFER (continued)

When Resample Image is checked, Photoshop will resize the image according to the values that you've put in for the width and height of the document size. When Resample is checked, the photo's file size will change. Because most of the time you'll want to make a file smaller, you'll choose Bicubic Sharper. (Bicubic Sharper is the most efficient way for Photoshop to interpolate the photo's pixels so that it remains sharp when you downsize it.) The values will be up to you. Just remember that the resolution for most web photographs is 72 pixels/inch. For most print jobs, you'll want a resolution from 200 to 300 pixels/inch.

Finally, Scale Styles has to do with layer styles. This setting, checked or unchecked, will have no effect on your resizing.

When you're working with programs other than Photoshop/Elements, resizing is a similar process. For example, to resize photos in iPhoto, you navigate to File > Export. The Export Photos dialog box will come up. If you open the Kind drop-down menu, you'll have a choice of photo formats. Navigate to JPEG and choose Small if you're going to use the images on the Internet or Full Size if you are going to print them. You have choices for the quality and size for exporting your files. The smallest file you can make is about 8 KB—that's if you choose a small, low-quality photo. The sizes go up from there.

Synching Your Phone

After you've taken some pictures using your iPhone, you'll probably want to play around with some apps. Apps are kind of like mini image processing programs that you can tweak your photos with. They are written about in detail later in this book.

In this section, you'll learn how to sync what you've got on your computer with your iPhone. Because we are only dealing with images here, that's all we'll use the synching for.

It's best to have the newest version of iTunes to synch your iPhone to your computer.

To synch your iPhone to your computer, connect the two using the USB cable that came with your iPhone. Next, open iTunes. In the frame to the left in the iTunes window, click on the name of your iPhone in the Devices tab.

A window will come up in which you'll see all the info about your iPhone, along with tabs at the top to perform specific operations. Figure 1.22 shows the window.

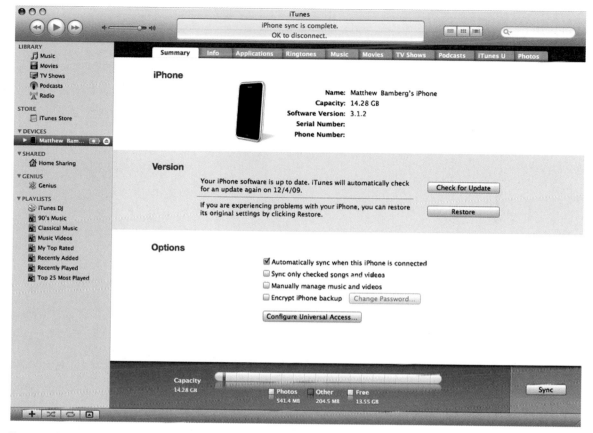

Figure 1.22 You'll use this window to upgrade your iPhone software.

Your iPhone should automatically sync with your computer once you've opened iTunes. If it doesn't navigate to File > Sync *your name's* iPhone.

Getting or Buying Apps

If you want to get a free app or buy a cheap one (most are cheap), follow these steps if you're shopping on your computer. (You can also buy apps from your iPhone, which we'll discuss in Chapter 7.)

1. Click on iTunes Store and click on Browse. (If you ever get a screen other than the iTunes Store during your shopping, just click on iTunes Store in the left frame again to get back to the store.)

2. To see a list of all the photography apps, navigate to App Store > Photography. Figure 1.23 shows the window that will show up after you navigate to the Photography section of the App Store.

Figure 1.23 The Photography section of the iTunes app store.

3. To find a specific app, just type in that app's name in the Search box. (Try photoshop, for example.)

4. Click on the app from those listed to read about it and then click where it says Get App (for free apps) or Buy App (for low-cost apps).

5. Next, you'll be prompted to sign in or to create a new account. If it's the latter, click on the Create New Account button. If it's the former, sign in to get or buy the app.

6. After you create a new account, a window will come up welcoming you to the iTunes Store. Click Continue, then accept the Terms and Conditions, and then click Continue again.

7. Next, you'll have to sign in (see Figure 1.24).

Figure 1.24 Signing in can be confusing. Choose Apple ID and enter the email address and password you entered when you registered.

NOTE

If at any time you get a message saying that your email is already registered, click Forgot Password if the system doesn't accept the one you gave it.

8. In the sign-in boxes, enter your email address and password. A window will come up, saying your sign in was successful. Or, if it's your first time signing in, a prompt will come up, asking you for security info. Make sure you fill in the additional information that allows you to reset your password.

9. Next go to iTunes App Store.

10. Sign into your account.

11. If you haven't used iTunes before, provide the information requested in the window and click Continue. Your iTunes store will then be created.

12. You can get descriptions of an app by clicking on it in the list in the left or right frame.

13. Click on the Get App or Buy App button to download. It will seem like nothing's happening but the app is downloading for sure. To find out how you get charged for buying an app see the sidebar below.

14. To get the app to your iPhone, navigate to File > Sync *your name*'s iPhone.

FINDING AND PAYING FOR APPS

You can find apps by searching for them or by browsing the Top Apps sections in the iTunes Photography Store. Note that if you click on any app in the Top Paid Apps or Top Free Apps list, you'll get a description of that app. On the description page, there will be a Buy App or Get App button to download the app. If you click on any of the Buy App or Get App application buttons anywhere in the store, the apps will be downloaded immediately.

When you choose to buy an app by clicking on Buy App, iTunes will ask you "Are you sure you want to buy and download (*the name of the app*)?" Below that, it will say, "Your credit card will be charged for this purpose and your application will be downloaded immediately."

You might ask, "What credit card?" Because when you registered for iTunes, you never gave them a credit card number. Well, it's the credit card you used to pay for your iPhone if you bought it at an AT&T Store.

You can check which credit card is being charged or enter/change your account info by navigating to Store > View My Account. You'll get a prompt to sign in again. After you sign in, you'll get a window like the one shown in Figure 1.25, with all of your account information and buttons to change anything you want, including the credit card you use to pay for your apps.

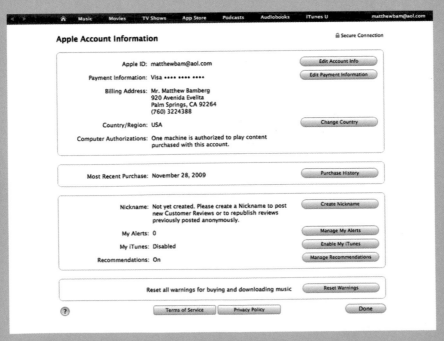

Figure 1.25 It's easy to find information about your account.

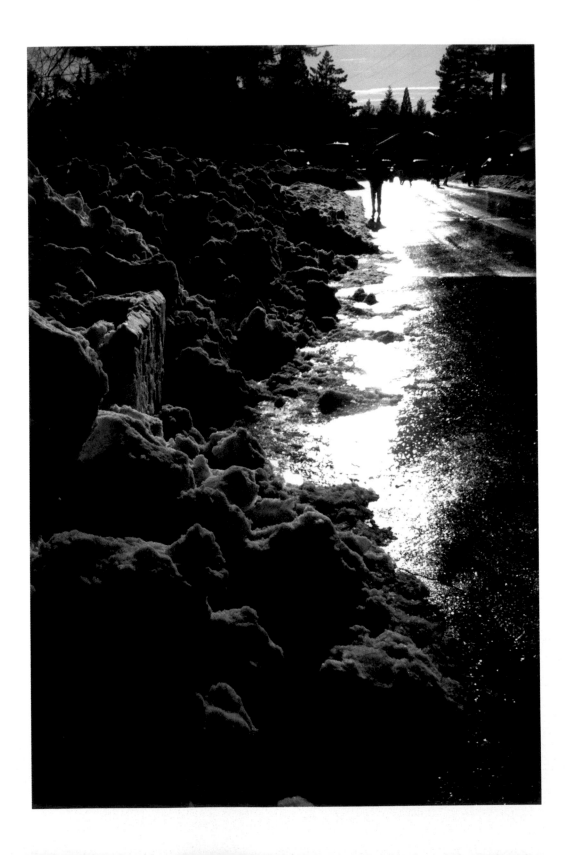

CHAPTER 2

Using the iPhone Camera

Now that you know the nuts and bolts of the iPhone and how to sync your computer and buy or get the apps, you're ready to take killer photos.

In this section you'll learn how to focus and expose your iPhone photographs as well as how to use the tap focus on the iPhone 3GS. Don't miss a section, either, because there are all kinds of things to note and numerous tips to getting the results you want from your iPhone camera.

Taking a Picture

Taking a picture with an iPhone is easy. The first thing you have to remember is that the lens of the camera is on the left-hand corner on the back of the phone (as you're looking at the back). You can take pictures in portrait or landscape mode (see Figures 2.1 and 2.2).

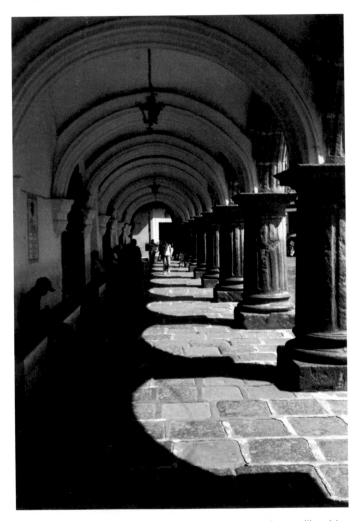

Figure 2.1 Hold the camera upright to take a picture like this one in portrait mode.

Figure 2.2 Turn the camera counterclockwise to take a picture in landscape mode.

To take a picture in portrait mode, turn on and unlock the camera and tap on the Camera icon on the home screen. Hold up the camera so that the touch screen is facing you with the Home button at the bottom of the camera. The camera will automatically show you whatever the lens is picking up. To take a picture, frame it and then tap on the Camera button on the bottom of the touch screen. The camera will take the picture after your finger is released from the button, not when it first touches it. If you want, you can touch the button for a period of time while you focus, and the shutter will not be released. It is only released when you take your finger off of the button.

NOTE

It's best to hold the camera with both hands to avoid blur from shaking the camera.

To take a picture in landscape mode, turn the camera 90 degrees counterclockwise (with the touch screen facing you), and it will automatically orient your framing to a landscape. When you've turned the camera around to take a picture in landscape mode, it's easy for your fingers to block the lens. To avoid that, just hold the camera on the right side.

If you're using an iPhone 3GS, you can take a picture using the steps just outlined. But, you can do one more thing before you tap on the Camera button. You can touch anywhere on the screen to focus on that point. The camera will automatically take that spot and make it the sharpest spot in your photo. For more information about the tap focus, see iPhone 3GS Tap Focus later in this chapter.

Viewing Photos

To view photos, just tap on the Photos icon on the home screen. You'll be taken to your Photo Albums screen. If you have no albums, all of your images will be in the Camera Roll. If you tap on Camera Roll or an album, you'll be taken to a grid of thumbnails of your pictures. You can swipe the screen up or down to see more of your images. Figure 2.3 shows the part of the grid in which images are displayed from a Camera Roll or album.

Figure 2.3 A grid of images is displayed for you to quickly see the photos you have taken.

You can tap on any of the images on the touch screen to see it at full size. You can also swipe across the screen to see image after image in consecutive order. When you're in Camera mode, you can tap in the lower-left corner to get to your Camera Roll.

N O T E

If you want to delete an image, tap on it in the Camera Roll and then tap on the trash can icon. A Delete Photo button and a Cancel button will pop up. Tap on Delete Photo to put the picture in the trash.

When viewing photos, webpages, email, or maps, you can zoom in and out. Pinch your fingers apart to zoom in; pinch your fingers together to zoom out. You can also double-tap (tap twice quickly) to zoom in all the way and then double-tap again to zoom back out.

iPhone 3G Fixed Focus

The iPhone 3G uses an area in the center of the touch screen to both focus and determine exposure. The way it focuses is determined in the same way the iPhone 3GS focuses without tapping. It will use the entire frame to focus and expose your image.

Since the focus point on the iPhone 3G is fixed, most of the time the entire image is either in or out of focus because the camera focuses on the entire frame. In other words, you're not likely to get a blurred background when you take a portrait.

Figure 2.4 shows two girls posing in the portico of a church in Tapachula, Mexico. Note that the background is sharp in that picture. The background is sharp because the lens is very short, so you always get a large depth of field (a large part of the frame is in focus).

Figure 2.4 A fixed-focus lens can't blur backgrounds.

iPhone 3GS Tap Focus

The iPhone 3GS has a tap focus, which lets you focus anywhere on the touch screen when you are framing an image by tapping on the spot where you want the camera to focus.

How much of the frame is sharp depends upon where you select your autofocus point (the part of the screen you are tapping) and how far the point you chose is from the lens. If the point you chose is far from the lens, you're not likely to get much softness in part of your image.

You can, however, get part of your image sharp and part of it soft if your lens (and focus point) is close to what you are shooting.

Figure 2.5 shows you two of the possibilities for creating a small depth of field with the iPhone 3GS camera. (See the upcoming "What Is Depth of Field" sidebar.) In both images, the lens and focus point are close to the object, so you have more leeway in making part of your image sharp and part of it soft. When you tap on a spot on the camera, you'll see a square grid come up, like the ones shown in the images. You can see where in the image the focus takes place (upon tapping the screen when the shot was taken). In the figures, the square grid also shows you the location of the part of the frame that was tapped. You can see the difference in focus between both images, which was the result of them being tapped in different places.

Figure 2.5 You can change focus points using the iPhone 3GS camera.

WHAT IS DEPTH OF FIELD?

On a dSLR camera, there's a setting called *Aperture Priority* mode. When that camera is in Av (or A) mode, it determines the shutter speed according to what aperture you've chosen to give you the best exposure. The iPhone 3G and 3GS work as if they were in Aperture Priority mode with the aperture set to 2.8. This value means that the lens on both types of iPhone cameras is open wide when the shutter release button is pressed.

This also means that sometimes you'll only get part of your image sharp, like that seen in Figure 2.6. In this picture, the first lamp at the top of the image is sharp, and the rest of them are not. You have more control over the depth of field with the iPhone 3GS because of the tap focus. I tapped on the first lamp to get only that part of the image sharp, thus making the depth of field small in the image. In Figure 2.7, the focus point was set on the boat, which is far away from the lens and which is in the middle of the frame—both of these factors cause the entire frame to be sharp.

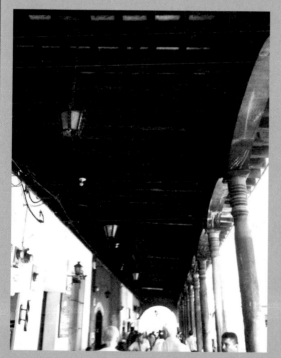

Figure 2.6 When only part of the image is sharp as the first lamp in the row of lamps is, it is said to have a small depth of field.

Figure 2.7 This picture of a cruise ship has a large depth of field, which means most (if not all) of the frame is in sharp focus.

Not only does the camera focus on a selected spot on the image (contained on a square that appears on the screen when you are framing your shot), it also uses that spot to calculate an exposure. The exposure is figured from the amount of light that is contained in the square that shows up on the touch screen when you tap on it.

> **NOTE**
>
> If you don't tap the screen at all when you are framing your image, the camera is set to an Automatic mode, where it will focus the whole frame.

Much like a dSLR camera, the iPhone 3GS camera determines an exposure based upon the light around the spot upon which you are focusing. Expose on a dark spot, and your picture will become lighter. Expose on a light spot, and your picture will become darker.

You risk overexposing your sky if you tap on a darker area of land when framing your image. If you want your sky to be filled with details, tap on a light area of it.

When you use touch focus, you can add more light to your frame (overexpose) by tapping on a darker spot within it (see Figure 2.8). If you want to take away light from your frame (underexpose), tap on a lighter spot (see Figure 2.9).

Figure 2.8 Tap on a dark area of the frame and your picture will come out lighter.

Figure 2.9 Tap on a light area, and your picture will come out darker.

Figure 2.8 shows a scene in Guatemala. The exposure is lighter because the darker area of the scene (the plants in the foreground) was the point of focus (and exposure). In Figure 2.9, the light area of the image, a point in the sky, was the point of focus (and exposure). If you're a person who likes detail in your sky, as I do, than you'll opt for the latter method of exposure.

iPhone Macro

With the macro lens on the iPhone 3GS, you can get a sharp shot up close (up to 10 cm). Figure 2.10 shows what you can do with a good subject. This conch shell was one of dozens cemented around a fountain. The trick to getting a good shot of one of the shells was finding a conch shell that had direct sunlight cast upon it. To take the shot, I held the iPhone camera about four inches from the shell.

Figure 2.10 The iPhone 3GS has a great macro lens.

Holding the Camera for a Sharp Shot

There are two things that you can do to ensure a sharp shot with an iPhone. One is holding the camera correctly, and the other is getting sufficient light.

The best advice for getting a sharp shot is to hold the camera with both hands. Figure 2.11 shows a sharp subject without blur from camera shake (shaking the camera when you shoot). The iPhone camera absolutely needs good light. When the light is good, the automatic ISO speed is adjusted downward. For more about ISO speed, see the upcoming "Getting the Lowest ISO Speeds Should Be Your Primary Goal When Shooting" sidebar. With the iPhone 3G, which has no touch focus/exposure, the only way you can control the light coming through the lens is by moving the camera around. If you're framing a shot, don't be afraid to move things around until the camera has a nice focus on it. If this isn't possible, tilt and angle the camera to get the most light inside the frame.

Figure 2.11 Hold the iPhone tightly with both hands for a sharp shot.

GETTING THE LOWEST ISO SPEEDS SHOULD BE YOUR PRIMARY GOAL WHEN SHOOTING

Everyone knows that the iPhone camera has no flash. For many novice photographers, the flash is the most essential element of their camera. Some never turn it off, letting the camera decide when it's necessary to use it. Many times it goes off when it isn't needed—for example, when you shoot in the shade, turning your subject/object flat and lifeless.

Because the iPhone has no flash, the developers worked out a way to sharpen an image in low light without using a flash. Unfortunately it doesn't work terribly well. The method has to do with the adjustment of the ISO speed when the amount of light changes in the frame. The ISO speed is a measure of how sensitive the sensor is to light. When there is ample light, the camera will automatically set the ISO to a low number (around 100 to 200). When there is little light, the camera will set it to a higher value (around 1000).

Working without a Zoom Lens

Using a camera without a zoom lens requires that you be creative when working with settings and subjects/objects. For example, if you are a candid photographer who shoots people without them knowing it, a zoom lens works well because you can shoot people from a distance. You'd think that if you take a picture *without* having a zoom lens, it would be kind of hard to photograph people without them knowing it, but the opposite is true. When you hold up your iPhone camera in front of someone to photograph them, it can appear that you are texting someone or just playing with your phone. Most of the time, they won't even notice you. Whether you decide to photograph people without their permission is up to you. It's not always the best thing to do; however, some of the most famous photographers have done it.

Now, if people know you are photographing them and you get them in good light without any distracting background, you'll get a really good portrait on the iPhone without zooming in from farther away. Figure 2.12 shows what you can get when your subject is close to the lens. Note how the face fills the frame completely so that there is no distracting background, taking away from the subject in the photograph.

Figure 2.12 Framing your subject tightly will eliminate a distracting background.

If you don't frame your subject tightly in the frame, you risk getting a distracting background. Figure 2.13 shows a woman in front of a distracting background—the huge trunk of the tree. If she was cropped tightly into the frame by holding the camera closer to her face, that background could be eliminated.

Figure 2.13 The tree looks as if it is coming out of the subject's head.

NOTE

If you want a background that is less distracting, you can always move your subject, or you can move around your subject, stopping when the background contains no distractions.

Better Photos on an iPhone

The iPhone camera is a funny device. Often, in order to get a good image, you have to turn every which way until you get the light right, something you don't usually do with other cameras. When you take a photo with an iPhone, it's best to move around yourself or move your subject/object around so you can place it in the best possible light and background.

Before you start using the iPhone apps, which will be discussed in the later chapters of this book, you should experiment with the camera to get the best possible photos you can. Apps will work better when your photos are ship-shape. Don't be afraid to do anything with your iPhone camera to get a picture, short of throwing it around or submerging it in water. You can get compelling photos under the weirdest of circumstances if you're on the lookout for them.

Lighting for Sharp Photos

So far we've touched on lighting for iPhone photos. There are some really cool lighting options you can use in various apps that are discussed later in this book.

For unprocessed shots, there's a lot you can do to get proper lighting for sharp shots, shots without haze, and shots without blown highlights. In traditional photography, photographs that contain noise, blown highlights, blur throughout the frame, and hazy casts aren't considered good. Here I present them as alternatives because with phone camera photography, these photographic conditions can sometimes be seen as compelling effects.

There are umpteen ways in which iPhone tends to use light. Although it might seem that getting a good shot (I'm not saying sharp here, because some photographic conditions like those mentioned a moment ago can make for a compelling shot) is like a roll of the dice, there are ways to manipulate the light to get that WOW photo you might be shooting for.

If you want a near-perfect outside shot with an iPhone, you should have the sun behind you on a clear, pollution-free day to get an image as sharp as the one shown in Figure 3.1. In this photo, it was important to have the entire frame sharp because of the ship in the background. It's the focal point of the image. The curves in the foreground are sharp, too. Their purpose is to bring your eyes through the frame to the ship.

There are also different ways to use light when you are out of the direct sunlight. Many websites and books tell you to photograph subjects/objects/settings in the shade, but that's not all there is to it. Even when you're in the shade, any light coming toward your lens from the front or sides will likely give you special effects that you might or might not want—white streaks, haze, and glare.

Tropical light, such as what you see coming from the left edge of the image in Figure 3.2, is intense. It can seep in through the slightest of openings, turning your entire frame hazy. Unless you want a hazy image (it can be an interesting effect), frame your shot so that no light seeps in and hits the lens of your camera.

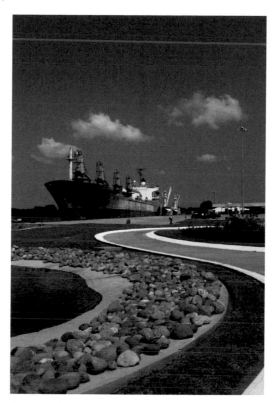

Figure 3.1 Having the sun behind you will keep the sky a gradient from blue to dark blue.

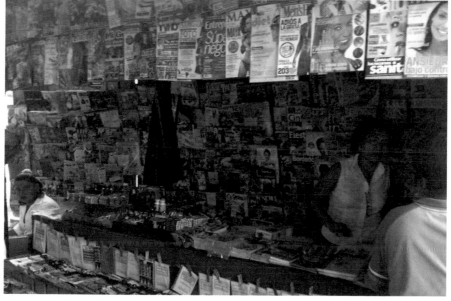

Figure 3.2 A hazy photo is caused by the lens seeing the sun.

The best way to shoot in the shade is with the light coming from behind you onto your subject. In the shade, you'll have ample light without wiping out part of your subject with shadows cast over the face from hair and the nose. Figure 3.3 shows optimal lighting for an iPhone photo. The light comes from behind the lens (at the photographer's back), casting beautifully onto the subject, who stands in the shade. Also, note the reflection in the sunglasses and the unique background.

Figure 3.3 Good lighting should include the sun being cast evenly on the subject.

NOTE
What it comes down to in terms of street photography is that, if possible, you should always shoot away from the street (in toward the buildings) when you're on a shady sidewalk.

Closing In on Objects

Whether your subject is a person or an object, you'll want to get as close as you can for a number of reasons. The first is that the iPhone 3GS has a lens that can take photos up close. (Some sample photos of the iPhone's macro capabilities are shown in Chapter 5, "Photographing Places and Things.") The second reason is because you can't zoom in on objects, so in order to get it big enough, you have to get close. The third reason is to get the details that parts of objects offer.

Figure 3.4 shows a close-up of the back of a chair that has a painting on it. The iPhone camera picked up the paint's pigment extraordinarily well.

Figure 3.4 Close in on furniture designs.

In Figure 3.5, there are some apples shot from close up. This still life is one of many types you can take of fruit. The iPhone camera picked up the color and the smooth, waxy texture of the apples well. Because this photo was taken with the iPhone 3GS camera, which has tap focus, you have part of the image sharp and part soft. The shot was taken by angling the camera to get the best light that was being reflected off of the apples.

Figure 3.5 Close in on a bowl of fruit.

Using an iPhone, you can close in on almost anything with just so-so light. Don't be afraid to experiment when you see a design on something you like or you find a still life. You'll quite possibly get a better image of the design than the one you are shooting.

Adding Bright Colors to the Frame

Colors in iPhone photos come out beautifully under good lighting conditions.

You can take the most offbeat subjects, hold up your iPhone to them, and come up with what looks like a masterpiece of photography. Figure 3.6 shows the inside of a tool shed. Several elements in the photo help to make it compelling.

- Tools are laid out randomly yet neatly in two rows, with a surprising abstract orange design connecting the rows.
- The hard edges of the tools come out as a kind of paradoxical play between texture and color—bright, fun colors among some serious tools.
- Other shades of orange included in the frame—in the scissors and the glue—match the abstract design in the middle.

- The placement of those alternative shades of orange one-third from the left side of the frame looks compelling because it follows the Rule of Thirds, which we'll discuss more later in the chapter.

- Topping it all off is the text that says "Paper Only," which gives a small narrative that this person's tools are well taken care of.

Figure 3.6 Find different tones of one color in the frame.

Even though the image in Figure 3.6 wasn't taken in the best of lighting (lighting in a garage is mediocre at best), it still came out fairly sharp. Not bad for a camera phone.

You can find bright colors balanced in signage and still lifes. Getting good photographs of signage with an iPhone is difficult. Usually signs are so high up that the 37mm (35mm equivalent) iPhone lens fails to get close enough so that the sign takes up a good part of the frame, enabling all of the lettering to show up sharp in the frame.

If you look at Figure 3.7, there's a Coca-Cola sign in the background. When I took the image, I walked as far as I could toward it, to the closest point at which I could see the image free of obstructions. The iPhone could only catch the sign as a small portion of a frame that's filled with the buildings around it.

Figure 3.7 Signs above buildings can't be shot up close with an iPhone.

If I had a zoom lens, I could have caught the sign up close so you could see the layers of paper from which it was made. (I did, in fact, catch the sign using my Canon 5D with a 70-300mm Tamron zoom lens.)

Now that you know that signs aren't great subjects for the iPhone (unless they are at ground level), we can move on to still lifes, which can be caught in all of their glory.

Still lifes can be found all around you if you look hard enough and have a sharp eye for design. That eye can be developed when you know what you are looking for.

A good still life should include objects with a variety of geometrical shapes and matching colors.

Geometrical shapes don't have to match each other in a still life. Just about any pattern goes. If you have repeating geometrical shapes, all the better. They increase the aesthetic value of a design in a still life.

Colors are a bit more complex to match than geometrical shapes are. There are certain color arrangements that work well together because of color theory factors. (Color theory is the science of color design.)

NOTE

The colors in a rainbow that match each other (when looked upon in a wheel, these are colors that are opposite each other) include blue and orange, green and red, and yellow and violet. These are called *complementary colors*.

Designers know these colors well; they match them all the time in webpages, signage, interiors of houses, and so on.

Figure 3.8 shows a picture where the colors match. The prominent geometrical shapes in the image stand out because of their color. The blue-green of the table is a perfect match for the red-orange of the floorboard.

Figure 3.8 Geometrical shapes filled with color can be found in many places.

The similar tones of blues also match somewhat. The rest of the colors, except the brown, are nearly neutral—colors that will match anything. Although the browns of the chairs don't match exactly, they provide good contrast with the rest of the colors in the frame.

It all makes for a great still life.

There are certain places in the world where you can photograph buildings with bright colors. Many of them are in Latin America and the Caribbean, where painting buildings with bright colors is a common practice. Figure 3.9 shows part of a welcome arch in Grand Turk. The iPhone camera lens picks up colors brilliantly when the sun is shining directly on a surface, as shown in the image. Note the dark-blue sky, the yellow-orange building, and the green door. In contrast to the bright colors are the fronds of the palm tree, which sit in the shade, with the darker tones caused by them being in the shade.

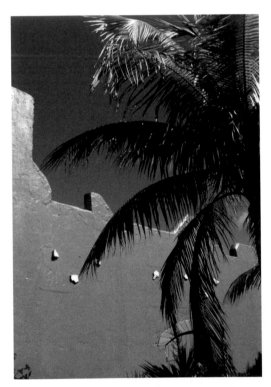

Figure 3.9 Optimal lighting conditions will cause colors to saturate.

If you look closely at the image, the orange is blown out, meaning it's so bright that it becomes the same shade throughout much of the wall when the shade should vary somewhat. Also, with blown-out colors, any texture you had in a surface will disappear.

When an iPhone image is taken in good light, salvaging the color so both the tonality and the texture of the surface come back is a possibility when you use a hue/saturation app, such as the Photoshop Mobile app, or almost any image processing software (such as that found in Photoshop or iPhoto). Figure 3.10 shows the image in Figure 3.9 with the saturation lowered (−20 in Photoshop). You can now see the tonality of color in the wall as well as the texture.

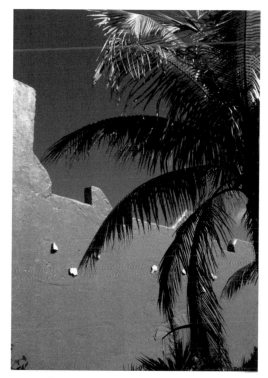

Figure 3.10 Blown colors can be salvaged by lowering the saturation in an iPhone app.

With any other digital camera, I would not have included the palm tree fronds in the frame, as I would have zoomed in to catch the orange wall against the deep-blue sky. In this shot I had no choice but to include the palm tree fronds because of the 37mm constant focal length of the camera—a camera with no zoom lens. After I framed the image in a way I ordinarily wouldn't, I found that the iPhone camera showed me that added elements to a shot like this (in this case, the palm fronds) can make for a better picture than I would have thought possible.

Using the Rule of Thirds to Frame Photos

If you place items in an image one-third from the top or bottom or one-third from the left or right of the edge of the frame, you're following the Rule of Thirds. The rule has been passed down from generation to generation. It was created to keep the focus off the center of the frame by not placing important compositional elements there.

No one knows exactly where the rule came from, but they do know it originated from similar rules that the ancient Greeks used.

In Figures 3.11 and 3.12, you see the Rule of Thirds used in two different ways. In Figure 3.11, you can see that the image was framed so that the primary object lies one-third from the left edge of the frame. In Figure 3.12, you can see that the line that makes the top of the suitcase is located one-third from the top edge of the frame.

Figure 3.11 The main object of the image is one-third from the left side of the frame.

Figure 3.12 Two-thirds of the frame is filled with the suitcase.

Sometimes the Rule of Thirds is used to find an exact placement of a part of a shot. If you look at Figure 3.13, you'll find that the center of the wheel was placed so that it aligns not only one-third of the way from the left edge of the frame, but also one-third of the way up from the bottom of the frame, almost at the intersection point of the two lines shown in the figure.

Figure 3.13 Sometimes the Rule of Thirds works by placing the center of an object where lines intersect.

Since eyes are the most important feature in a portrait, the Rule of Thirds is often used to place them. Figure 3.14 shows a portrait where the eyes are placed one-third from the top of the frame. For more about portraits, see Chapter 4, "Portraits."

In photography, many believe that rules are made to be broken. If you spot a shot where the subject looks great in the center of the frame, by all means frame it that way. Figure 3.15 shows a woman who is placed in the area of the image with the most light. The light in the middle gives the woman a kind of angelic look.

Figure 3.14 Eyes in a portrait are often placed according to the Rule of Thirds.

Figure 3.15 The Rules of Thirds is broken, with the woman placed in the center of the frame.

Trying a Worm's-Eye View

This one you have to bend down for. When people are walking by or when people are dancing, stoop as low as you can go with your iPhone camera and shoot with your camera pointing slightly upward. You'll find that among your shots, you'll get interesting movement blur (especially in low light) and angles of the people moving about.

Don't worry if you don't get the entire bodies of the people you're shooting. Body parts are perfectly acceptable as subjects to be framed. In Figure 3.16, an image of a woman walking in front of a dance floor, there are dancers in the background that help set the atmosphere for the picture.

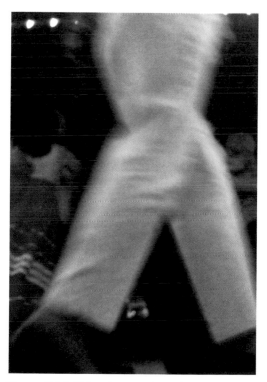

Figure 3.16 Take pictures down low to get a worm's-eye view of people.

The 20th-century photographer, Lisette Model, perfected this technique in many of her photographs. For more about this technique and myriad others taken from 20th-century photographers, see the book *101 Quick and Easy Ideas Taken from the Master Photographers of the Twentieth Century* (Course Technology PTR, 2009).

CHAPTER 4
Portraits

P robably the most common use for an iPhone camera is to take portraits of people. If you compose a portrait carefully, you can make it look better than a simple snapshot.

When evaluating light, you'll find that there are a couple of things to watch out for when taking a portrait. Haze and blown highlights are some of the demons you can encounter when shooting a portrait.

Once you have determined that your lighting is sufficient for a decent image, you can apply the techniques in this part of the book for a memorable portrait.

Ready for Your Close-Up?

In the movie *Sunset Boulevard*, Gloria Swanson plays Norma Desmond, a washed-up movie star. In the last scene of the movie, she moves into the camera and says, "All right, Mr. DeMille, I'm ready for my close-up." It certainly is apropos to begin this chapter with that line.

Although the iPhone takes a pretty sharp image of a person close up (see Figure 4.1), it does have a bit of barrel distortion. Barrel distortion is caused by the curvature of the lens. In extreme close-up portraits, it will exaggerate the nose.

Figure 4.1 You get some distortion when you photograph close up with an iPhone.

Have Your Subject Do Something

You'll get good results in your photos of people when you do three things:

- Photograph them from up close
- Have them doing something
- Have a nondistracting background

Figure 4.2 shows a woman not only smiling, but also tipping her hat. The placement of her arms and hands ends up framing her face as well as showing an action. Because the photo was taken close up, you can see details in her features—eyes, teeth, and lips, as well as the lines of her hands and the weaving in her hat.

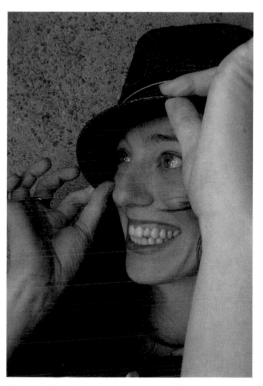

Figure 4.2 Having your subject doing something can make a portrait more compelling.

Shooting a Person inside a Vehicle

You can spell out almost any style you want by photographing people inside a vehicle. From people sitting in horse-drawn wagons to people in sports cars, the vehicle will determine the style of photograph you shoot.

You can see two totally different styles in Figure 4.3. The contemporary car provides a sporty backdrop for a portrait. The tractor sets the stage for a blast from the past because it is an antique vehicle.

Figure 4.3 A vehicle makes an interesting setting for a shot.

Figure 4.4 has a person in a vehicle and doing something. He pauses for a moment for a snap-shot inside a taxi while looking for money in his wallet to pay the driver.

Figure 4.4 A person in a vehicle doing something.

Simplifying Your Background

Having too much clutter in your background can take away from your subject (see Chapter 2). You can have subjects stand in front of solid-color walls or photograph them so that the background consists of neutral colors.

Figure 4.5 shows a portrait taken with a concrete-wall background. This background is optimal because it has a small amount of texture to it. The picture is sharp because it was lit with studio lights. Figure 4.6, also taken with studio lights, shows what happens when you have an all-white background. All-white backgrounds tend to reflect light (instead of absorb), so they show up lit unevenly.

Figure 4.5 Find a background that's a solid, neutral color.

Figure 4.6 All-white backgrounds can cause vignetting in an image taken with an iPhone.

> **NOTE**
> White backgrounds tend to cause *vignetting*, or shadows around the periphery of the frame.

If there is no background with a solid color, you can find backgrounds that consist of neutral colors. You can see how the colors pop out in Figure 4.7 because the background consists of neutral colors. The reds of the meat are almost shocking. The shirt and towel over the man's shoulder are radiant.

Figure 4.7 Colors will stand out if you find neutral backgrounds.

Positioning Your Subject

The way in which you place your subject can change how people will interpret the image. In Figure 4.8, the subject is positioned with his body turned clockwise about 45 degrees, and his head is then turned toward the camera. This is a standard portrait position. Figure 4.9 shows a variation of that position with the subject touching her hat in kind of a stylized action with her hand.

Another common way to position your subject is to have him or her facing the camera. To make that shot more interesting, you can follow the Rule of Thirds by placing your subject off center in the frame. Figure 4.10 shows the subject to the left of the center of the frame so that the middle of his face and body lie one-third from the left side of the frame.

Figure 4.8 A common way of positioning your subject for a portrait.

Figure 4.9 Stylized hand movement over hat.

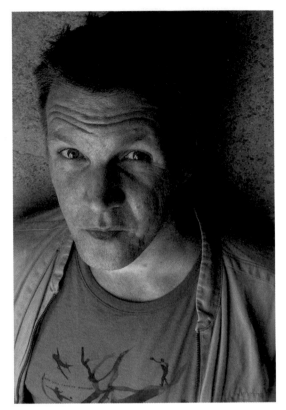

Figure 4.10 Follow the Rule of Thirds when subject faces the lens.

You can also have your subject position himself in a natural way. If you want a shot that is sweet, get one filled with slumber. I'm not talking about someone just lying down in a bed. I'm speaking of a close-up—a headshot—of a person lying down on a soft pillow with her eyes closed. When composing your shot with the iPhone camera, think about filling the left corner of the frame with part of the pillow. It's okay if part of the forehead is covered by it. Turn the camera to landscape mode and frame just the face, neck, and a small part of the chest. Make sure no clothing shows up in the frame. If you are successful, you might come up with a portrait like you see in Figure 4.11. In that picture, note how the head and features can be symmetrically cut with a diagonal line that runs from the lower-left to upper-right corner of the frame.

For positioning more than one subject in the frame, see the upcoming "Positioning Groups of Two and Three" section.

Figure 4.11 A person sleeping can create a compelling scene.

COLOR SPLASHING YOUR SURROUNDINGS

Greg Ketchum manipulates his photos both on his computer with iPhoto and on his iPhone with different apps. He has many of his photos synched with his computer so that he can manipulate them in both places.

For this example, Ketchum starts with the photo shown in Figure 4.12. His first tweaks come in iPhoto, which include increasing the exposure and the contrast sliders to get an image like that shown in Figure 4.13.

Figure 4.12 Image without any modifications.

(continued)

COLOR SPLASHING YOUR SURROUNDINGS (continued)

Figure 4.13 Image after adjusting exposure, brightness, and contrast in iPhoto.

Ketchum then syncs his iPhone to his computer (see Chapter 1) to get the tweaked photo onto his iPhone. He opens up the ColorSplash app by tapping on its icon.

ColorSplash automatically turns the image into black and white. Ketchum then paints the color back into whatever part of the photo he wants by using his finger, to get an image like that shown in Figure 4.14. "It's like finger-painting," he says. "It only restores the color to areas that you touch; it doesn't add new color."

Figure 4.14 Image after tweaking in ColorSplash.

Creating Interesting Backgrounds

There's another way you can go about selecting a background other than simplifying it—by choosing to use a vast landscape as a backdrop for your subject. Figure 4.15 shows AT&T Park as a backdrop for a portrait of a woman, creating an image with a sporting theme. The background is so vast that it really doesn't interfere with the subject. There are no obstacles coming out of her head, nor is there anything too busy behind her, because the photographer framed the photo so her head is in front of the green grass of the field.

Figure 4.15 Having your subject pose in front of an interesting backdrop can make for a dramatic photo.

Another interesting background is one created in a store. You have to be careful to position the subject so that nothing is coming out of his or her head, though. The man in Figure 4.16 is positioned so that the background in the vicinity of his head is just blue wall. There is a red item to the left side of his face, but it's far enough behind him that it doesn't interrupt the flow of the image. The other items on the wall add interest to the shot, as does what's in the left part of the frame.

Figure 4.16 Create space between the background and the subject.

Positioning Groups of Two and Three

One way to add depth to portraits of more than one person is to place one subject behind another. Figures 4.17 and 4.18 show how placing one of the subjects behind adds depth to the frame.

Figure 4.17 In a three-shot, pay attention to positioning your subjects, the clothing the subjects wear, and their smiles.

Figure 4.18 Two brothers in Antigua, Guatemala.

There are many more techniques that can go into shots of multiple people—everything from the positioning of heads to how the subjects wear their clothes.

Lighting is an important factor, too. In Figure 4.18, the subjects were shot without much thought to the composition. The boys were photographed on the spot in Antigua, Guatemala. Sometimes, as in this photo, the subjects will place themselves, leading to a pleasing composition.

In Figure 4.17, more thought was put into the composition, from the clothes the subjects are wearing to the poses they assume in the frame. Not only is one of the subjects behind the others, but also the subjects' poses are well balanced in the frame. The subject on the right has her head tilted toward the other two subjects, and the subject on the left is placed closely behind the man who sits just off center in the frame, which puts all of them closer together so that there are no gaps.

With more than three people in a photo, there are dozens of ways to position your subjects. If your subjects have taken a lot of photos with people in them, they'll already have an eye for placing themselves in a photo.

NOISEBLASTER DECENT APP TO GET RID OF NOISE

Getting rid of noise is something everyone wants to do after they take a photo with an iPhone. One program, NoiseBlaster, does a decent job of eliminating the pesky color dots that are noise in the frame. The app also doesn't take your resolution down much. For a photo taken with the iPhone 3GS, it only drops the resolution to 1600×1200. (You can lower resolution even more in the Settings menu.) In Figure 4.19, there is noise in the photo, a fact of life for photos taken at night with an iPhone. In Figure 4.20, the noise is almost all gone. In Figure 4.20, the Denoise option was applied, which is simply a slider that you drag to increase denoising. The options under Colors were also used, which include Exposure and Contrast sliders. The exposure was decreased by moving the slider to the left, and the contrast was increased by moving the slider to the right.

Figure 4.19 Night photo before applying NoiseBlaster options.

Figure 4.20 Night photo after applying NoiseBlaster options.

Having Subjects Interact

Earlier in this chapter, we found that a subject doing something can make a frame more compelling. In a two-shot (or shots of more than two people), you can have your subjects interacting.

In Figure 4.21, two people are engaged in the art of cosmetics—one applying makeup to the other. Most notable in the image are the position of the girl's eyes as she is being made up. Other elements stand out, too—the clear view of the makeup case, the color match of the towel and the girl's top, and the view of the hands, one in which the palm is visible and the other in which the back of the hand is visible.

Figure 4.21 Having subjects interact creates a mini narrative.

There's another way to get great images of people interacting, and that's to take a picture of a picture of people interacting. Yes, that's right! You can find images posted on walls in hotels, marketplaces (especially historical ones that have been around for a long time), and casinos. (I've actually photographed wallpaper that was made of images of famous movie stars of yesteryear.)

Tucked into the corner of the Farmers Market in Los Angeles are huge retro-looking images from when the market opened decades ago. The pictures have no frames. They are just posted on a board with lamination, making a great medium to photograph, because you don't get any glare.

In the picture of a picture of a scene from the market (Figure 4.22), there is much interaction going on. There's so much going on that it could be an image straight out of a child's social studies book. A farmer (or so as it appears) offers a woman fresh tomatoes, who in turn shows them to another woman friend. The two women are placed close together In the right side of the frame, and both of them are separated from the farmer by the box of tomatoes he is holding up. What makes this photo so interesting is that the women are dressed to the nines, something that you rarely see today at the Farmers Market.

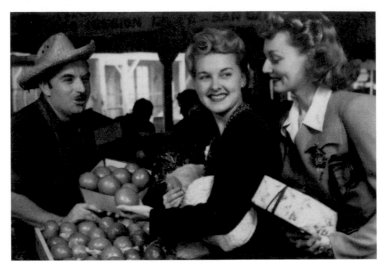

Figure 4.22 The iPhone does an excellent job of taking photographs of other photographs.

ANIMALS IN ACTION

People aren't the only ones who interact with each other. Animals do, too, and dogs do it well. If you have a pet, you'll want to catch it in action. Although the iPhone camera probably won't freeze the animal action, it will provide a decent enough image to show your friends and post online. You can take shots that show motion blur with sharp backgrounds, like that shown in Figure 4.23.

Figure 4.23 Although the iPhone won't freeze fast-moving subjects, it will show motion blur with a sharp background.

Shooting at an Angle

Shooting at an angle can make a portrait come alive. We're not talking about just tilting your camera a little bit; we're aiming for some serious diagonal framing. Figure 4.24 shows what you can do in terms of varying your angle.

Figure 4.24 You can turn your iPhone to shoot subjects at an angle.

Sometimes you can catch groups of people at an angle. This works especially well when you are photographing people sitting in a row, like those you see in Figure 4.25.

You'll notice that Figure 4.25 follows the Rule of Thirds (see Chapter 3), with vacant floor covering the lower one-third of the frame. If you look at Figure 4.26, the shot isn't nearly as interesting when taken with the camera straight up and down.

Figure 4.25 Groups of people sitting together can be shot at an angle.

Figure 4.26 Sometimes shots taken with the camera positioned straight up and down can be boring.

You can combine both shooting at an angle and creating a beautiful background in a portrait to come up with a picture like the one shown in Figure 4.27. The woman's portrait was taken at an angle with a sunny beach background.

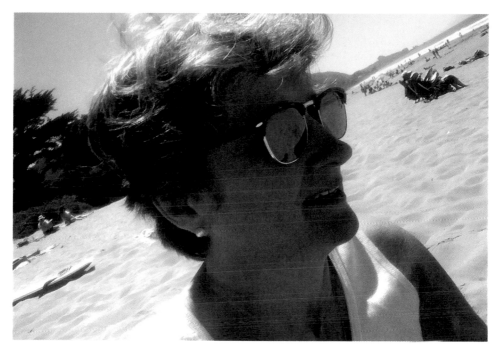

Figure 4.27 A portrait with a beach background shot at an angle.

iPHONE SHOWS MOVEMENT

If you look at Figure 4.26, you'll find that the image is boring because (in addition to not being shot at an angle) it just doesn't have enough happening in it. Add a person to the foreground, and you've created an interesting shot. Add one moving, and your frame comes alive, as shown in Figure 4.28. When subjects are moving indoors, the iPhone camera does rather well at blurring them. This is because since less light is available, the iPhone automatically increases the shutter speed, causing motion blur from the shutter being open longer. The more light in a frame, the less the iPhone will blur a moving object.

Figure 4.28 The iPhone camera blurs motion indoors.

Photographing Body Parts

When you're looking around for interesting things to photograph with your iPhone, look for and isolate body parts. From a person's feet to only her eyes, filling the frame with just one body part (or a repetition of the same body part on several people) captures something that turns out to be a great examination of humankind. The iPhone 3GS does incredibly well photographing body parts up close, and the 3G is almost as good.

Figure 4.29 shows a row of people's legs and feet. This image keeps viewers glued to the frame, looking at the different kinds of shoes and pants the people are wearing. This also shows that you can get much closer to people when you photograph with an iPhone than if you photograph with a regular camera. Normally, the people in this picture might have objected to having a stranger take a shot of them. However, they were unaware they were the subject of an image because the photograph was taken when the photographer was looking like he was playing around with the device (when he was actually taking a picture).

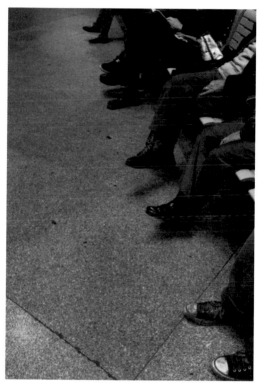

Figure 4.29 A row of people's feet isolated in the frame highlights shoe types.

You can also isolate shoes on an interesting background, like the tennis shoes shown in Figure 4.30. The black-and-white checkerboard floor adds to the various colors that make up the shoes. The shot has a kind of rough-and-tumble look because of the wear (the big hole) lining the sole of the shoe. The colors of the shoelaces, blue jeans, and soles of the tennis shoes contrast well both with each other and with the patterned floor tiles. Last and most important in this shot is the texture. You can almost feel the socks that lie inside the ripped cloth of the tennis shoes, as well as the metal holes through which the shoelaces are woven and the cloth of the shoelaces themselves.

Figure 4.30 Isolating shoes among a compelling background in a
frame highlights their color and texture.

Any part of the body can be framed and photographed with an iPhone up close (see Figures
4.31 to 4.34). Many well-known photographers have photographed their subjects so that only a
part of the face is framed. They do this to bring up the fact that emotion can be expressed in the
eyes or mouth of a person. Another common practice among these photographers is to photo-
graph a person without showing the head.

Figure 4.31 A close-up of the hand
can highlight jewelry being worn.

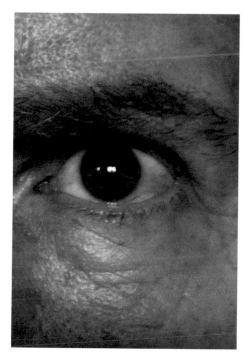

Figure 4.32 A close-up of an eye is like an illustration of the human experience.

Figure 4.33 A close-up of the mouth can highlight a smile.

Figure 4.34 Including only the torso in the frame can highlight clothes the subject is wearing.

Photographing Places and Things

Once you've got your iPhone in your pocket, you've become a roving photographer, able to catch the essence of life around you. From finding action on the street to catching the hue in flowers, you'll find that the camera will take pictures of remarkable quality if you follow the tips in this chapter. I've peppered the chapter with some samples of what you can do with the great apps available for the iPhone. The camera apps are covered in greater detail in Chapters 7, 8, and 9.

Working with Flowers

Flowers are a perfect match for the iPhone's macro lens. The lens will give you a sharp image as close as 2.5 inches away from a subject. And the iPhone will refocus as you get closer to the subject, something other camera phones don't do.

However, don't expect to get a good flower shot with an iPhone the first time. You really have to get about 10 shots of a flower at all different angles to get one compelling shot out of the bunch. Figure 5.1 is the best out of a set of about 10 photos I shot. The light is just right—there are no blown color highlights nor solid black shadows. The petals are silky smooth.

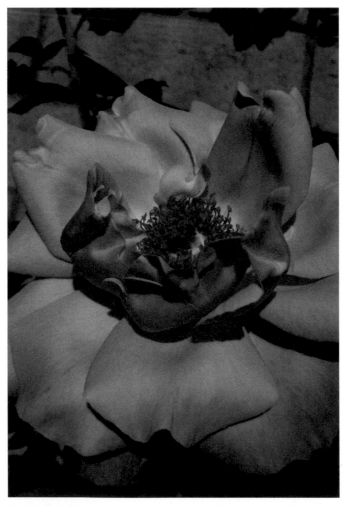

Figure 5.1 You have to experiment to find just the right type of light to get a killer flower photo.

Many times in gardens and in front of homes, there are pots filled with flowers. Capturing such flowers among a compelling background makes for a great image. In Figure 5.2, a pot of flowers is the main subject. The setting—the bricks upon which the pot sits and the modern Florida home background—adds to the beauty of the photo.

Figure 5.2 Make a pot of flowers the main subject of your photo.

To get this shot, I took several images of the home from different angles and different positions. The one in which the pot of flowers is the focal point turned out to be the best. Also of interest is the framing. You only see the trunks of the palm trees. Their lines add strength to the photo. (Vertical lines are symbols of strength.)

Sometimes flowers can produce fascinating shadows. In Figure 5.3, the pistil of a hibiscus is casting a strong shadow on the petals. It's the first thing that catches your eye when you see the photo (which is quite detailed because of the iPhone's macro lens). You even have to study the picture a bit to find the actual pistil because it blends in with the petals. The iPhone 3GS does a great job of photographing flowers in the sunlight.

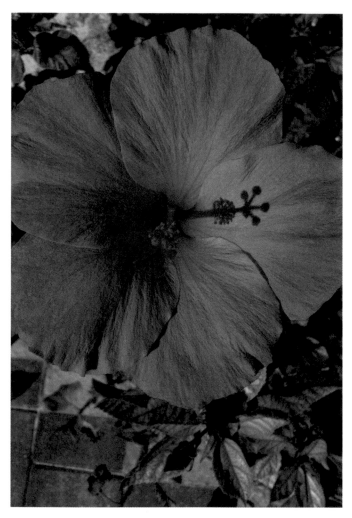

Figure 5.3 Shadows of a part of a flower onto the flower itself can be powerful.

SKETCHING IN PHOTOSHOP MOBILE

You can turn a photograph into a sketch using Photoshop Mobile. All you do is open PS Mobile, pull up the flower you want sketched (say, a flower like you see in Figure 5.4), and then navigate to the Sketch option in the top menu bar. To vary your sketch, you slide your finger across the screen. When you're finished tweaking your flower (playing around with moving your finger across the screen), navigate to Save and Exit, and voilà, you have a sketched flower like the one you see in Figure 5.5. The nice thing about PS Mobile is that the program doesn't reduce the resolution of the tweaked photo, making it a prime candidate for blowing up and hanging on your wall. For a complete how-to on the app, see Chapter 9.

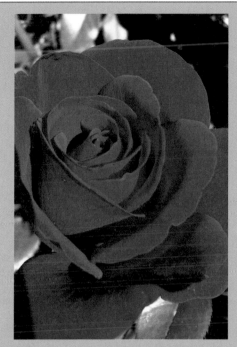

Figure 5.4 Flower before using the Sketch option in PS Mobile.

Figure 5.5 Flower after tweaking using the Sketch option in PS Mobile.

Photographing Architecture

The iPhone's lens (focal length 37mm equivalent) permits you to fit giant buildings into your frame. Keep it in portrait mode to fit in tall buildings and in landscape mode to fit in wide buildings.

The first thing you want to do to get a compelling architecture shot is to keep the sun behind you. It's best if the sun is cast upon the building you are shooting. Figure 5.6 shows a building shot lit by the sun. Note that the sky is blue behind the building. That only happens when the sun is on the other side of the sky from where you are shooting.

Figure 5.6 Architecture shots should be taken with the sun behind you.

You can vary your architecture shots in the following ways, still remembering to shoot so that the sun is cast upon the building to get that much-needed blue sky in the shot.

You'll want to get a good balance of contrast between building and sky when the sky has beautiful clouds. To get a picture evenly exposed, you can tap around on the iPhone 3GS and tilt/angle/move your camera on the iPhone 3G. If you tap on the sky to expose your photo on the 3GS, you'll get a dark building below. If you tap on the building, you'll get an overexposed sky, as shown in Figure 5.7.

Figure 5.7 You'll get an overexposed sky if you tap on a dark building.

To get better contrast in your entire frame, building and sky, tap on a place that's neither too light (like the sky) nor too dark (like the building). In Figure 5.8, I tapped the roof of the building so that both the sky and the building would be exposed better. When the sky is as compelling as the one you see in the figure, you'll want to tap around so that it is exposed correctly, while watching that the building doesn't get underexposed. If you're using an iPhone 3GS, you can tilt and turn the camera to get the best overall exposure.

Figure 5.8 You'll get a more evenly exposed photo if you tap an area where the light is neither light nor dark.

Just as with any camera, when you tilt the iPhone upward when taking a photo, you'll get converging lines in the frame. In Figure 5.9, you can see how the columns in the frame lean in toward each other. This happens because of the orientation of the lens with respect to the building. (The camera was tilted upward to take the picture.) Because you'll probably be tilting your camera upward when you're taking a photo of a building, all the lines that building makes will converge into each other as you move up the frame (unless you photograph the building from above, in which case the lines will converge into each other as you move down the frame).

Figure 5.9 When you tilt your camera upward, you'll get converging lines in the frame.

One way to avoid converging lines is to shoot architecture from a distance, as shown in Figure 5.10. When you're a bit away from the building you are photographing, you don't have to tilt your camera.

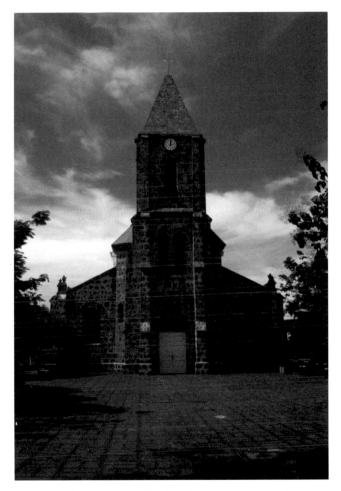

Figure 5.10 A picture of a church with no converging lines.

Sometimes it's just not possible to keep lines from converging in a photo. Finding a place to photograph buildings so that lines don't converge in the frame can be a challenge. The building in Figure 5.11 was shot from across the street, some distance away from the structure. The iPhone still created converging lines in the frame. In this photo, though, the lines are compelling because they repeat and offer a pattern in which the middle line is straight up and down, and the lines to the left and right of that line fall toward to it. Adding to the interest of this photo is that each balcony contains an interesting vignette, which keeps you looking around the frame to see what's there.

Figure 5.11 Converging lines can be interesting.

Finally, there are times when converging lines serve the iPhone photographer well. In Figure 5.12, two buildings are joined at a line that connects one building whose face contains murals of people on balconies and the side of a building that contains empty balconies. If the image contained only the mural as it was seen straight on without converging lines, it wouldn't have been nearly as interesting as seeing the perspective of the images as they get smaller as you go up in the frame, with the empty balconies on one side and the blue sky on the other.

If you frame two structures of similar designs, you're bound to bore your viewer. Contrast usually provides the human eye with a vivid experience. A building of mundane architecture can be made more interesting by including another structure or building of different, more elaborate design.

In Figure 5.13, the bottom part of the Golden Gate Bridge has been framed with one of the buildings beside it. The curves and vertical and diagonal lines of the bridge's steel work contrast with the tan building's nondescript design. Also impressive is the negative space—the color and shape of the sky above and below the bridge, the top a triangle of darker blue and the bottom a semicircle of lighter blue.

Figure 5.12 Unique painted building in Spain.

Figure 5.13 Part of the Golden Gate Bridge in San Francisco and a building beside it.

In Figure 5.14, the tower at Park Güell is framed with a lamp that has a red sign attached to it with some graffiti on it. If only the tower was included, the shot would look like any tourist took it, but frame it with the stylized lamppost, and you have yourself the beginning of a work of art. Add the bit of graffiti as shown in the shot, and you're telling a story about how man's markings can range from the artful and complex (the tower and lamp) to the simple and juvenile (the red sign tagged with someone's name).

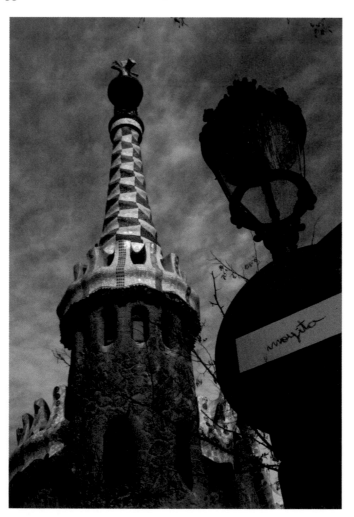

Figure 5.14 The tower at Barcelona's Park Güell with a lamp beside it.

Finally, there is the issue of framing architectural elements—isolating them, if you will, examining shape, texture, and form. If you see something up high on a building that you'd like to isolate in a frame, you're out of luck. The iPhone doesn't have a zoom lens, and unless you're Spider-Man, you're not likely to get a picture of an exterior building up high. But this doesn't mean you can't take close-up art shots of architectural elements. Figure 5.15 shows a thick iron fence set against wooden doors. It's a nice picture, to be sure. It's the added element—the reflection of the thick iron—that really makes the shot. If you look around, you can not only take beautiful close-up shots of architecture (as long as you can get your iPhone near the element), but you can also usually find that something extra that will make your picture a "Wow!" photo.

Figure 5.15 Frame architectural details.

POST-PROCESSING: INCREASING INDIVIDUAL COLOR SATURATION

If you look at Figure 5.13, you'll find that the colors are dull. You can change this by tweaking the saturation in either PS Mobile if you're post-processing on your iPhone or Photoshop/Elements if you're post-processing on your computer. The contrast in Figure 5.16 has been deepened by increasing the saturation of the reds in Photoshop (Image > Adjustments > Hue/Saturation; choose Reds from the Edit menu). In PS Mobile, tap on Saturation (it's part of a drop-down menu of the second icon at the top of the screen) and slide your finger to the right (positive numbers will appear at the top of the screen) until you reach the saturation that you like.

Figure 5.16 Figure 5.13 after post-processing.

INVERT WITH PIXEL PERFECT

Pixel Perfect can invert your images to create dramatic results. Figure 5.17 shows an unevenly exposed architectural image before applying the Invert option in Pixel Perfect. The image has a dramatic sky but also has a foreground that is too dark. It also has blasting highlights where the sun is setting in the background. You can change the color of the image at the same time as you enhance the contrast so the shot becomes dramatic by using the Invert option in Pixel Perfect. Figure 5.18 shows a stunningly surreal inverted image of Figure 5.17. The blown highlights have been converted to dark shades of black and blue, and the sky has changed to a uniquely Martian-like shade with an eerie red glow. This is highly contrasted with the white buildings and streets that illuminate the foreground.

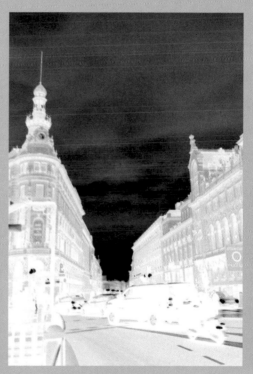

Figure 5.17 Architectural image before running it through Pixel Perfect.

Figure 5.18 Architectural image after using the Invert option in Pixel Perfect.

Photographing Landscapes

If you're looking to fit vast landscapes into the frame using your iPhone, consider yourself lucky. The iPhone lens allows you to include a good amount of scenery in your frame. Figure 5.19 shows you just how much you can pack in—a wide stone balcony in the foreground, two large buildings in the middle ground, and several other buildings and a landscape in the background. Not bad for a tiny camera phone!

Figure 5.19 You can fit a lot of buildings into the frame with an iPhone lens.

The Rule of Thirds covered in Chapter 3 is also used in landscapes. Most of the time, photographers fill the frame with two-thirds land and one-third sky, as shown in the landscape of Toledo, Spain, in Figure 5.20. This rule can also apply when the sky doesn't extend fully from the left to the right of the frame, as shown in Figure 5.21.

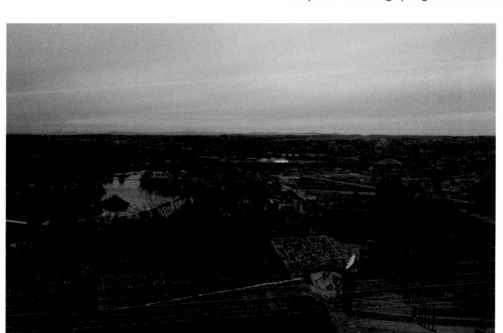

Figure 5.20 The Rule of Thirds is used to determine how much of the sky is placed in the frame.

Figure 5.21 The Rule of Thirds applied to a partial sky.

You have to work with the iPhone to get a compelling landscape. The first thing to be aware of is that you can't home in on an area without using a Crop tool, which will ultimately give you a lower resolution.

The iPhone takes excellent landscape shots if you have ample light and if the sun is behind you, as in the mid-morning photo of the Panama Canal you see in Figure 5.22.

Figure 5.22 Mid-morning photo of the Panama Canal.

In this image, the entire frame is sharp regardless of where you tap on the iPhone 3GS, because the tap focus doesn't work when you're taking a landscape.

Many times when you look at an image, the first thing that happens is your eye wants to find the focal point. In Figure 5.23, the winding stairs lead to figures, which act as a focal point in the image. If the figures were not there, your eyes would be led to the outlook at the end of the stairs, which would then be the focal point of the image.

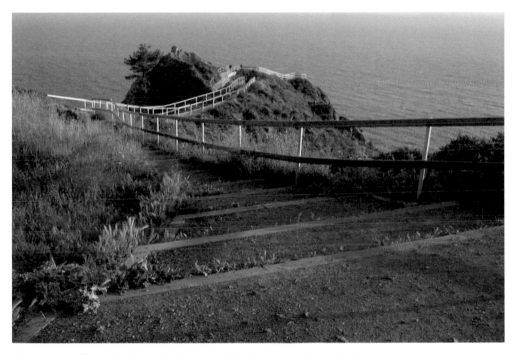

Figure 5.23 The winding stairs lead to a focal point at the end where the people are.

You can frame a landscape around an element in a photo to make it a focal point. Figure 5.24 shows greenery around a painter. Also helping the composition is the fact that the sun is shining where the painter is painting.

Figure 5.24 You can use a landscape to frame a person engaging in an activity such as painting.

Finally, think about incorporating the weather into your landscape by photographing in the fog—a weather event that can make a shot moody or mysterious, as shown in Figure 5.25.

Figure 5.25 Fog can make a photograph feel moody.

It's no secret that landscapes are more compelling during sunrise or sunset. There are a few tricks for using your iPhone to get a truly killer shot.

No matter how hard you try, an iPhone will not catch the sun in anything but the color white. (The same goes for any area of bright light.) It doesn't matter if the sun appears yellow or red on the horizon, it still will blow the highlights all the way to the color white. With this being the case, the best way to catch a colorful sunset or sunrise is when the sun has just slipped below or has not quite come up on the horizon, like the sunset shown in Figure 5.26. Figure 5.27 shows you the blown highlights that you get when you include the sun in the frame during sunset.

Figure 5.26 Don't include the sun in the frame.

Figure 5.27 You won't get golden suns with an iPhone camera.

NOTE

The three ways to get the most color out of an iPhone sunset or sunrise photo are to shoot in another part of the sky at sunrise or sunset when all of the colors appear, to wait until the sun is just below the horizon, or to shoot at sunrise or sunset when the sun is blocked by clouds.

GHOSTS AS SUBJECTS

The Ghost Capture app is perfect for almost any landscape photo. The app inserts a ghost in your image. You can choose the type of ghost you want from a small selection that the app offers. You also can control the transparency of the ghost with a slider. You can move the ghost around with your index finger. You can change the ghost's size by stretching or compressing it with your thumb and index finger. You can rotate the ghost by twirling your thumb and index finger. Figure 5.28 shows a landscape shot before I put in the ghost. Figure 5.29 shows the ghost inserted into the shot. Just as you place a main subject/object following the Rule of Thirds, you can place a focal point in the same way. Figure 5.29 does not follow this rule; however, it approximates it by having the ghost placed just off center in the frame, instead of one-third from either edge of the frame. Note that the resolution is very small—just 280×320 pixels, tiny by even Internet standards. The program shrinks the image dramatically after you save the image to your Camera Roll.

Figure 5.28 A landscape shot before the ghost is inserted.

Figure 5.29 The ghost inserted into the landscape shot using the Ghost Capture app.

Photography as Art

Still-life photography captures the essence of a man-made vignette of objects that can be found almost anywhere. Usually you'll take these pictures up close. Because the iPhone does well with close-up shots, you'll have a great time capturing still lifes. Figure 5.30 shows just how well an iPhone can take a close-up image through a store window.

Figure 5.30 Still life in store window.

In many circumstances the iPhone actually does better with still lifes than a dSLR camera does. The iPhone camera's wide aperture sharpens items in a still life more than many dSLR cameras with kit lenses can. (More expensive lenses remedy that problem.)

Window displays can offer many surprises. They can contain one or more still lifes. These displays can contain varying colors, shapes, and textures. Figure 5.31 contains a variety of colors, shapes, and textures. From the cellophane wrap to the rainbow colors and shapes that can fit snugly into the mouth, the entire picture looks scrumptious.

Figure 5.31 Window display of a candy store.

Closely related to still lifes is found art. You can find art almost anywhere you look, but you have to be discriminating about what you find. Skilled photographers find art by looking up close for things that, when photographed, look like a painting or some other form of art.

To find found art, you have to be a careful observer, looking in every nook and cranny around you. In Figure 5.32, what looks like a drawing was found in a door on a street in Toledo, Spain. The natural wood patterns in the door resemble an abstract drawing of a pair of dancers. There are circular patterns that frame the figures. The colors in the found art vary from white, to shades of brown, to black.

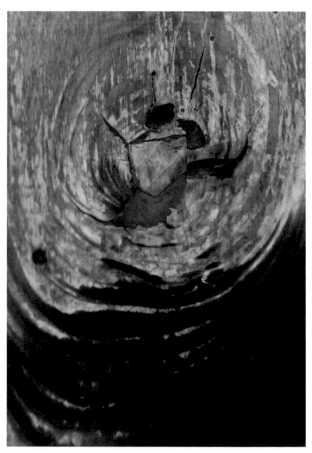

Figure 5.32 Because the iPhone does well photographing up close, it's a natural for photographing found art.

In Figure 5.33, I found a plaque embedded in the sidewalk with tiny interesting images molded into it.

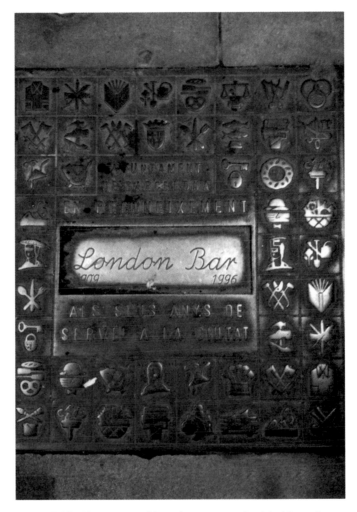

Figure 5.33 This piece of found art was embedded into the sidewalk on a street in Spain.

Street Photography

Street photography is a favorite pastime for many. The iPhone lets you capture scenes and events quickly. To be a good street photographer, you have to watch the events around you. They can be simple events that capture a given, such as someone sitting in a streetcar, or more complicated narratives. When you're out and about, be on the lookout for scenes that tell a story, such as that shown in Figure 5.34, where a woman is giving money to street musicians.

Or look for a scene like Figure 5.35, where a woman is shopping at a flea market. In the latter image, you'd be surprised by how close you can get to a subject with an iPhone without being recognized as a photographer. It's easy to be mistaken for someone who is doing some other task on the iPhone when you're taking a picture.

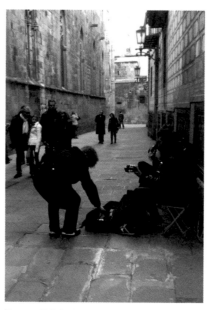

Figure 5.34 A woman giving money to musicians playing on the street.

Figure 5.35 A woman sorts through a flea market vendor's wares.

If you do find something interesting going on in the street, don't take one picture—take many. Scenes change quickly, and one mundane scene can get interesting really quickly.

The image in Figure 5.36 shows a boy sitting on a bench—cute but not too thrilling. In Figure 5.37, another boy gets his attention—an overall better picture because it creates an interesting narrative.

Figure 5.36 The first image of a series.

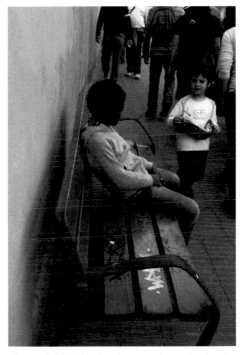

Figure 5.37 The last image of a series leads to the climax of one boy eyeing another.

If you put the camera near the ground, you can increase the perspective of your shot. In Barcelona, Spain, there is a wide pedestrian walkway called Las Ramblas. You can find many interesting street photography shots on a walk down this pathway. In Figure 5.38, the iPhone was set very close to the ground to take the picture. The perspective is enhanced by that simple action. This is called getting a *worm's-eye view* of a scene (the view a worm would get from the ground).

Figure 5.38 You get a worm's-eye view of the world when the picture is taken with the camera close to ground.

THE TILTSHIFT APP

One five-star app has to be TiltShift. It can add Gaussian or lens blur to your image almost anywhere you want. It works by moving one or two fingers on the screen. The amount of blur is controlled by a red ellipse. (There are other types of controls, but this one most closely emulates the way a lens would blur a photo.) The inside of the ellipse corresponds to what's sharp in the photo; outside of the ellipse is where the blur occurs. When you move one finger across the screen, the ellipse moves. Use two fingers, and you can control the size of the ellipse. Figure 5.39 shows an image before the TiltShift app was applied. Figure 5.40 shows the image after the ellipse was manipulated so that it was oriented to include only the people at the counter, thus keeping them sharp while the rest of the frame is blurred (with a lens blur). Finally, you can control the amount of blur with a slider. The best thing about the app is that you have a choice of resolutions in which to save, including the original resolution of the photo.

(continued)

Figure 5.39 An image before applying the TiltShift app.

Figure 5.40 The TiltShift app can make the subjects of a photo pop out by blurring part of the frame.

Working with Different Types of Light

The word *photography* comes from the Greek words *phos* and *graphis*, which mean "light" and "paintbrush"—or, in other words, drawing with light. Before you take a picture with the iPhone camera, you must assess the light around you. Whether it's light coming from the sun, light coming from a reflection of the sun off of a surface, or light coming from light bulbs indoors, the iPhone camera will use that light to determine both the shutter speed and the ISO speed (a reading dependent upon how sensitive the sensor is to the light). The results can range from incredibly sharp to a noisy blur. Using the light to get the best-exposed image possible takes some practice and skill. In this chapter you will learn some of the tricks of the trade for drawing with light with your iPhone camera.

Reflective Light

One thing many people never notice when walking around is reflections on surfaces of the world around them. Usually these reflections are not obvious. You have to look out for them. In Figure 6.1, the reflection of the sign in the puddle could have been missed because it could be seen only from a certain angle. In fact, you had to move around the puddle to get the reflection in its entirety.

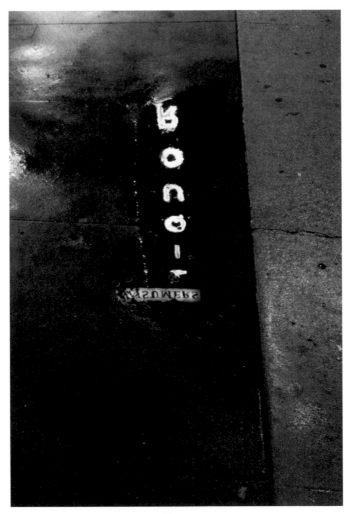

Figure 6.1 Reflection in a puddle right after a rainfall.

But it doesn't need to rain for you to find reflections. Reflections occur on many different types of surfaces—from the obvious, such as those found on water, to the subtle, such as those on plastic. They transform what's being reflected into something akin to a painting or drawing, depending on what the surface that's reflecting is like.

Reflections change the light from harsh and direct to soft and diffused. They can also drastically change the color of what's being reflected. In Figure 6.2, the background colors of the Seattle Space Needle reflection are changed to mysterious hues and tones, which depend on the color of the sheet metal. When surfaces are piecemeal, like the sheet metal in this image, each part of the frame can vary. Changes in the placement of the reflection can also occur, as you can see where the sheet metal pieces come together. You can see the misplacement of the Space Needle where the pieces of sheet metal meet in the top-right corner of the frame. You can also see that the top of the Needle rolls a bit so that there are bulges in the circle that it forms.

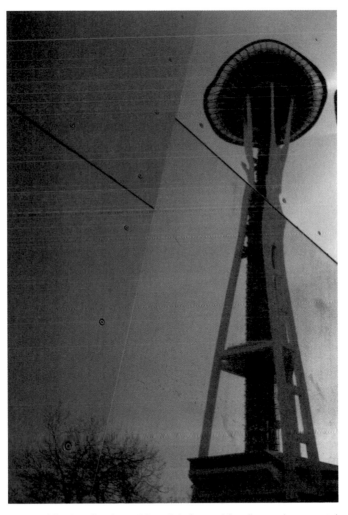

Figure 6.2 A reflection of Seattle's Space Needle on sheet metal.

Direct and Indirect Light

In an experiment done with the iPhone camera, I took a picture of a cactus in the sun and a picture of another cactus in the shade. Both pictures were taken at about the same time in Acapulco, Mexico, where the sun is pretty powerful. Unlike portraits, where shade is the best spot to take a photo (because you don't get any shadows on the face), many plants are best photographed in the sun because the shadows add depth to them, sometimes making them look three-dimensional. Figure 6.3 shows the cactus that was shot in the sun, and Figure 6.4 shows the cactus that was shot in the shade. The former looks fuller and multidimensional. The leaves also look sharper, even more dangerous than the latter's. Finally, one of the most important reasons why the cactus in the sunlight looks lush is because it has more color tones than the cactus in the shade. The color tones are doubled when you account for the tones formed by the shadow on the leaves.

Figure 6.3 A cactus photographed in direct sunlight.

Figure 6.4 A cactus photographed in the shade.

When you shoot in the sun, it's best to make sure the sun is behind you, as mentioned in Chapter 3. This ensures that your sky is blue if the weather is clear and that clouds will be visible if there are any. Another type of direct lighting situation occurs when the sun is coming in at an angle in photographs taken outside. If you're photographing subjects outside, having the sun come in at an angle will keep direct sunlight from getting into their eyes, which causes them to squint. Figure 6.5 shows a model being photographed in a scene lit with the sun coming in at an angle.

On cloudy days, you can get some very compelling images. The iPhone camera does well on cloudy days because the intensity of the light is muted, and it's spread around more evenly than on sunny days, when you can get harsh shadows and blown highlights. The quality of the images depends upon how cloudy it is and how much sun gets through. Figures 6.6 and 6.7 show two examples. In Figure 6.6, enough light is coming through the clouds to make the picture sharp and with good contrast. Figure 6.7 shows an image taken later in the day, when the sky was cloudy, leaving just enough light to make the dog sharp, but not enough light to see details in the fur.

Figure 6.5 Photograph subjects with direct light coming in at an angle.

Figure 6.6 When it's cloudy the light is diffused, creating an image with few, if any, shadows.

Figure 6.7 Details in the dog's fur are lost in this image taken later in the day.

As I mentioned before, the iPhone does not do well when you take pictures in indoor light. If you're photographing indoors, take your subject where there is direct sunlight coming through.

When you shoot subjects directly under the light, you'll get blown highlights on the head. Figure 6.8 shows this happening inside a subway car. However, it's not a photo to toss away, because the woman has an interesting look on her face.

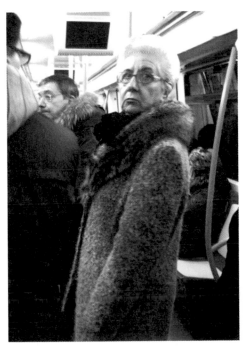

Figure 6.8 Photo of a woman directly under light.

Even though you might think there is adequate light indoors, the iPhone doesn't. It will adjust the ISO upward so that you get noise. However, you still can take a sharp photo and then use a de-noise app, such as NoiseBlaster (discussed in Chapter 4), to get an almost perfect photo. Figures 6.9 and 6.10 show how different a photo can be in quality when lit with indoor light versus when shot outdoors in indirect sunlight.

Figure 6.9 Image shot indoors.

Figure 6.10 Image shot outdoors in the shade.

Night Photography

It's too bad that the iPhone adjusts the ISO speed upward when you take a photo in low light. Although it does make the image sharper, an increase in noise is almost unavoidable. This is because the iPhone will automatically set the ISO speed to 1016 for photos taken at night. The high ISO setting will still occur if you keep your camera steady by using a camera holder.

The difference in quality of night photos varies with the distance your subjects/objects are from the lens and how much (man-made) light you have around you. If subjects/objects are far away, much detail in them will be missed, as shown with the people and monument in Figure 6.11. If subjects/objects are closer, more details show up, as shown in Figure 6.12, but still far fewer than you'll get during the day under the right conditions.

Figure 6.11 Few details show up in long shots of subjects/objects at night.

Even if there is abundant man-made light in a given scene at night, the iPhone will still set the ISO high (at 1016), producing not only noise, but also many areas of blown highlights, as shown in Figure 6.13.

Figure 6.12 You can see some details in this image of a boy selling grapes in Spain on New Year's Eve.

Figure 6.13 Noise is a common issue when photographing outside at night.

You might wonder if you can pick up trails from cars with an iPhone camera. The answer is yes, you can. If you photograph moving cars in the evening, holding your camera very still, you can get movement blur with a sharp background, as shown in Figure 6.14. The best time to get trails so you *do* get a sharp background is a few minutes after dusk, a time when there is still some light to keep the background sharp.

Figure 6.14 The iPhone camera is capable of creating trails.

NIGHT CAMERA FEVER

Night Camera is a so-so app that will sharpen your night photos. It does so by adding considerable noise; however, the sharpening power of this tool is outstanding. The app is great for sharpening photos you're going to send around the Internet. Three things happen with a photo when it's taken with Night Camera or after you've selected a photo from the Camera Roll to process. The first is that the resolution is dropped considerably from the normal resolution of an iPhone photo. The second is that if you're taking a picture in landscape mode, it will convert it to portrait mode, causing a loss of resolution because it adds black space above and below your photo. You'll have to crop with a crop app or in post-processing on your computer after you download the photo. The third is that it takes several seconds after you take the photo for Night Camera to process it, which makes it more difficult to take several photos in a row when the app is being used. See Figures 6.15 and 6.16 for a comparison of images taken with and without Night Camera.

Figure 6.15 Photo taken with the iPhone camera without using Night Camera.

(continued)

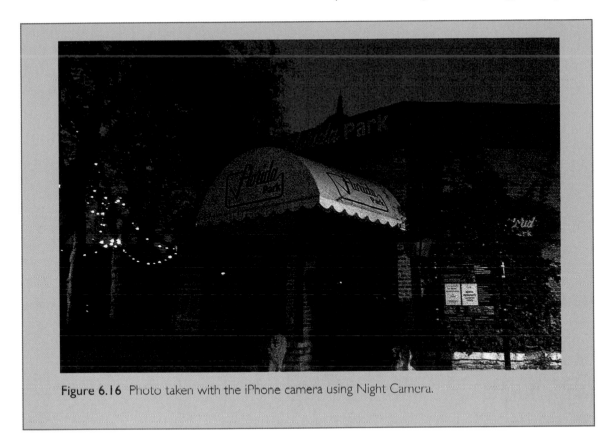

Figure 6.16 Photo taken with the iPhone camera using Night Camera.

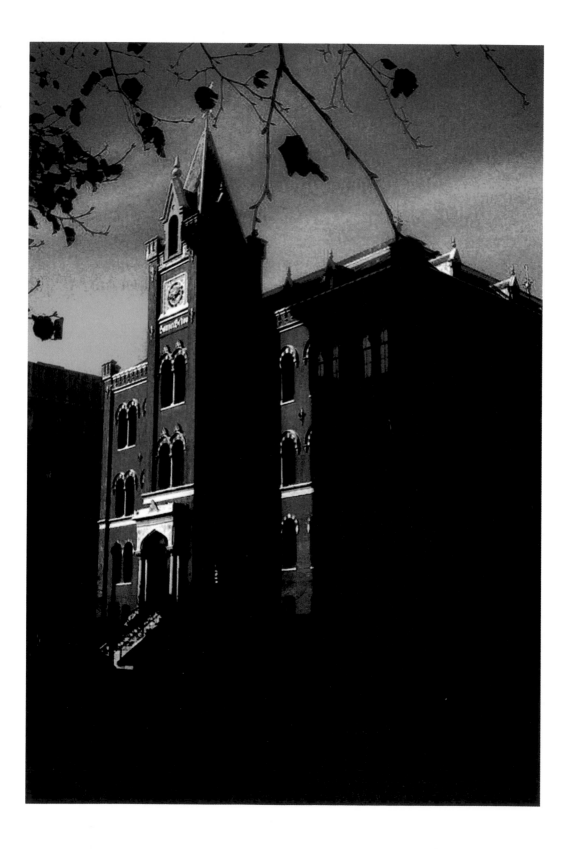

CHAPTER 7
All About Applications

So far, we have touched on a few applications (apps) in earlier chapters of the book. Apps can be divided into two general categories. The first are the ones that you activate while taking the picture so that you can control things such as digital zoom, stabilization, time to take a shot, and so on. These apps are discussed in this chapter.

The second type of apps includes those that you can use after a picture is taken. These are called post-processing apps. They are discussed in Chapters 8, 9, and 10.

Apps are a wonderful feature of the iPhone camera. Pictures taken or processed with apps have become somewhat of an art form. As you saw in the introduction, thousands of people are using apps and posting their manipulated images on Flickr.

Finally, apps are what makes the iPhone fun. By all means, have a good time when you play with them!

Downloading and Installing Apps from Your iPhone

In Chapter 1 you learned how to get free apps or buy apps in the Photography section of the App Store from your computer and move them over to your iPhone. You can also buy apps directly from your iPhone. All you do is tap on the App Store icon and search for the app you want.

NOTE

If you buy an app from the App Store, the credit card you have on file will be charged automatically.

UPDATING APPS

If you see a number in a red circle in the upper-right corner of the App Store icon, it means that the apps you have on your iPhone need updating. Figure 7.1 shows the location of the App Store icon and the number with the red circle around it. At the time this screenshot of the iPhone was taken, there were seven apps that needed updating. (The number indicates how many apps need updating.) When you tap on the App Store icon when it has a number in a red circle on it, you can update your apps. To do this, tap the Updates icon on the bottom-right of the screen. After you tap that icon, a list of the apps that need updating will be displayed. The list contains information about when the last update was made and what version of the app it is called. To make the update, tap the Update All button at the top-right corner of the screen. Figure 7.2 shows the list of apps and information about them, as well as the Updates icon you tap to get to that page and the Update All button in the top-right corner of the screen.

(continued)

Figure 7.1 The number inside the red circle in the top-right corner of the App Store icon means that there are seven apps that need updating.

Figure 7.2 List of apps that need updating.

The Photography Section of the iPhone App Store on Your iPhone

As mentioned in the previous section, you can buy photo apps from your iPhone or from your computer.

It helps to get the lay of the shopping land before you tap the Buy button, which automatically will charge your credit card for the amount of the app.

If you know the name of the app, you can tap the App Store icon and then tap the Search icon at the bottom of the screen.

If you just want a desultory look at what photography apps are available, tap the App Store icon and then tap the Categories icon at the bottom of the screen. Then swipe upward and tap Photography (Categories > Photography), as shown in Figure 7.3. Figure 7.4 shows some of the apps available, their cost, who created them, and their ratings. You can search apps by the top apps you pay for (Top Paid), by the Top Free, and by the date they were released (Release Date).

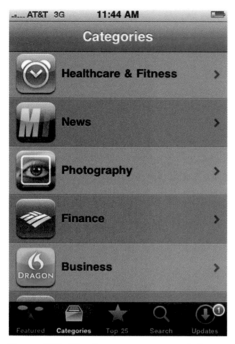

Figure 7.3 The best way to search for photo apps is to look in the Photography section of the App Store.

Figure 7.4 You can search apps by using three different parameters listed at the top of the screen, below the Photography heading.

NOTE

You can't list both the categories and the apps in alphabetical order, so swipe slowly so you don't miss the Photography category or the app that you're looking for.

Apps to Help You Take Photographs

Two apps—ProCamera and Camera Genius—are remarkable. From using complex voice recognition to using state-of-the-art stabilization, the apps simply help you to take killer pictures. One of the apps can be set to write your location on the photo. The following sections detail every aspect of these two apps to help you make the best use of them.

ProCamera

You can use ProCamera (which sells for $1.99) while you are taking pictures (see Figure 7.5). It has an anti-shake mechanism, 5X digital zoom in full resolution, a timer, and a full-screen trigger. There's a ProCamera app and a ProCamera Basic app. For the purposes of this book, we'll cover the Basic app.

Figure 7.5 Images taken with ProCamera's image stabilization system come out sharp even in low-light situations, as you can see in this picture of a painting by artist Ramiro Ortega.

ProCamera is fairly simple to work with. You just need to know a few things. One of the best things about this app is its steady shot feature. It can't be beat for capturing a sharp image with your iPhone.

There are three ways to take a picture using ProCamera:

- Tap anywhere on the screen to take the picture immediately. In the settings, you have the option to get a preview and then save (or not) or to automatically save the photo and take another one right away.

- Tap the Anti-Shake Camera icon. Tap this and hold the camera in front of your subject/object. Keep steady. When the camera senses that you are steady, it will take the shot.

- Tap the Timer Camera icon. The camera will wait a specified amount of time (which you set in the settings) before it takes a picture.

Figure 7.6 shows the Anti-Shake Camera and Timer Camera icons located at the bottom center and bottom right of the screen.

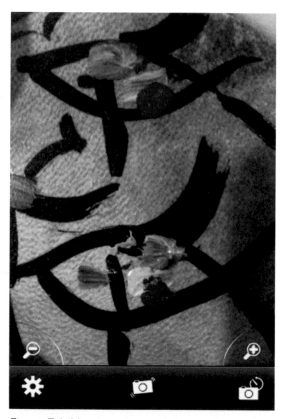

Figure 7.6 You can tap anywhere on the screen to take a picture with ProCamera.

In Figure 7.6, there is also a Gear icon, which takes you to the settings screen; a magnifying glass with a plus sign in it, which digitally zooms in; and a magnifying glass with a minus sign in it, which digitally zooms back out.

> **NOTE**
>
> Digital zooms don't work well; you're better off cropping the part you want to zoom into using a cropping app.

Knowing your options for using ProCamera will improve every image you take. Figure 7.7 shows the options you have when shooting with this app.

Figure 7.7 You'll want very specific settings when using this program.

The first setting is the anti-shake setting. You'll want to tap the last (right) icon of the three. These icons set the sensitivity of the camera. If you choose the last icon, the camera will only take a picture when it's very still, giving you the sharpest shot. The other two icons are less sensitive and will take your picture when there is some camera shake, not creating the best possible shot.

The second setting is the timer. You can set it from 1 to 20 seconds by swiping the slider to the right to increase the time it takes for the camera to automatically take a shot after you tap the Timer button.

The third setting is Auto Save. You can also consider this as an option to set whether you have a preview of your photo. If it's off, you'll be taken to a screen that gives you a preview of your image. There will be two icons at the bottom of the screen, as you can see in Figure 7.8. If you

want to keep the photo, you tap the disk icon. If you want to trash it, you tap the disk icon with a line through it. If the Auto Save button is on, you won't get a preview screen—you can just keep tapping to take one picture after another.

Figure 7.8 You have an option to get a preview of your photo and then to save or trash it when Auto Save is set to off.

> **NOTE**
>
> The iPhone will vibrate when it has finished saving your photo. The toolbar will change from red to green when saving is complete.

The fourth setting is Full-Res-Zoom. If it's on, your zoomed pictures will be saved at full resolution.

The fifth setting is the Pro Grid. If you set this to on, you'll get a grid on your screen to, say, take a picture using the Rule of Thirds (see Chapter 3).

NOTE

All images taken without using the digital zoom in ProCamera have the same full resolution as a picture taken by tapping the button in normal Camera mode.

Camera Genius

The next app that turns your camera into a mean machine is Camera Genius.

In this app you can turn on one or more options to help you to take a better picture. The options you can turn on by tapping on the arrow/list icon on the bottom-left corner of the screen are shown in the pop-up menu you see in Figure 7.9. You just tap the option you want to activate. To deactivate an option, you tap it again.

Figure 7.9 Zoom is selected from a list of options available in Camera Genius.

Also on the bottom of the screen is a shutter device button (the camera icon) and a double-rectangle icon, which takes you to your Camera Roll so you can preview your picture if you want. To get back to the camera from there, all you do is tap the Cancel button at the top right of the screen.

The following list details what each option does when it's selected.

- **Zoom.** This option allows you to zoom into an object by swiping a slider. Figure 7.10 shows the slider that you swipe to zoom in (swipe right) and zoom back out (swipe left).

Figure 7.10 Swipe the slider to zoom in on or out from an object.

- **Sound Capture.** This option lets you speak to take a picture. All you have to do is say "cheese." If you talk too much, it will keep taking pictures. Figure 7.11 shows the sound sensor. When it's green, a picture is taken. The red number in the upper-left corner of the frame shows how many pictures you have taken with your voice. If you tap it, you can clear it to 0. The Saving icon in the left corner means that the iPhone is saving the picture.

- **Anti Shake.** In this mode an anti-shake sensor is activated. Figure 7.12 shows how much shake there is in the camera. When it goes to red, it means you're trembling. When it dies all the way down, the camera automatically takes a picture.

- **Big Button.** When this is set, you can tap anywhere on the screen to take a picture. If only this option is selected, you won't see any indicators on the screen.

- **Guides.** You have your choice of six grids that you can overlay on your screen, as shown in Figure 7.13. In the figure, the diagonal guides have been selected from a pop-up menu at the bottom of the screen after tapping the Guides icon.

Figure 7.11 Say "cheese," and the camera will take a picture if the Sound Capture setting is used.

Figure 7.12 When the green diminishes, the camera is steady enough and takes a shot automatically in anti-shake mode.

Figure 7.13 You can choose from a number of guides to set up your shot.

■ **Timer.** You can set a loud beeping timer that goes off after you activate the shutter release. Figure 7.14 shows the screen before the shutter release is activated. The numbers count down from 10 after you activate the shutter release.

Figure 7.14 You can set a timer so that there is a wait time after the shutter is activated.

■ **Burst.** Once you set the camera to Burst mode, the screen is free of options. You just tap on the camera (if Big Button isn't selected) or on the screen (if Big Button is selected), and the camera will automatically take three pictures, one after another.

■ **Settings.** The settings only do two things. The first is that you can opt to have the location, date, and time on your photo. (Yes, the camera can find out where you are.) Figure 7.15 shows what the buttons look like after they are tapped. Tap to turn them on and off. Figure 7.16 shows where the location, date, and time are printed on the photograph. The last setting is Confirm Saving. When that's turned on, you'll get a screen with a preview of your picture and options to delete and save on either side of it. When Confirm Saving is set and the camera is in Burst mode, three previews of your image will appear on the screen, each with an red circle with a minus sign inside and with a blue circle with a check inside. The former option deletes the image; the latter saves it.

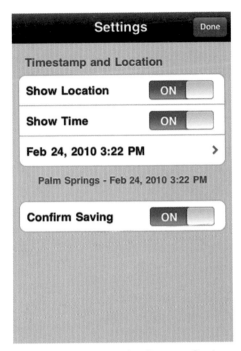

Figure 7.15 Settings for Camera Genius.

Figure 7.16 Location, date, and time shown on the bottom of the screen when those options are set in the settings.

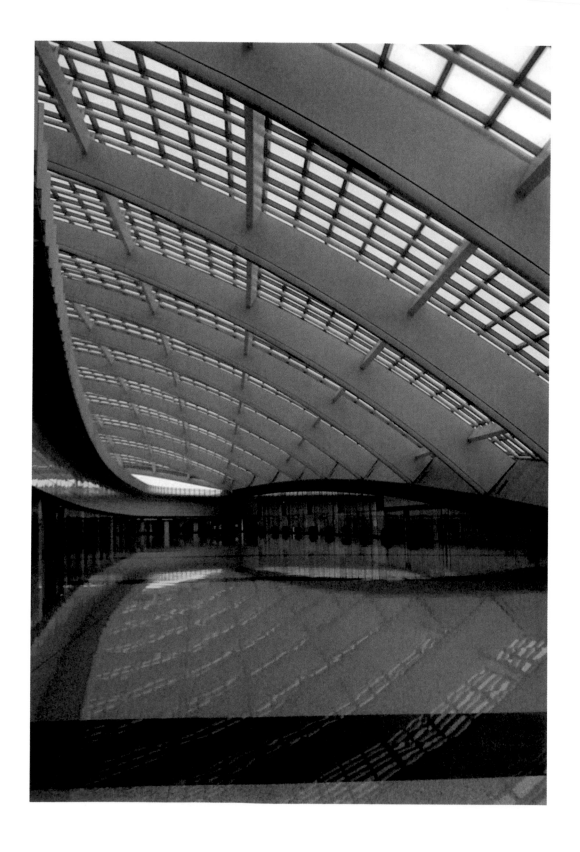

CHAPTER 8
Resizing, Cropping, Framing, and Printing Photos

There are dozens of programs/apps that will resize and/or crop your photos both on the iPhone and on your computer. In Chapter 1, we discussed resizing as part of the process of getting your photos from your computer to your iPhone. While cropping and resizing are options in many apps, I've chosen a few of the most popular to cover. Remember when cropping a photo to consider the aesthetics of your composition. Also, consider that the fact that when you crop, the resulting photo will be a lower resolution than the one you started with. But don't be afraid to experiment with your crops. Who knows? You might invent a new style that will become wildly popular. The medium of iPhone photography is just in its infancy.

Resizing on the iPhone

Whether you want to resize a photo to put it on a social networking site or you simply prefer to send smaller files when emailing photos, there's a wide variety of options for resizing your photos on the iPhone.

The easiest way to resize your photo—if that's all you want to do—is to use the free app called Simple Resize.

To resize in Simple Resize, tap on Library, choose the photo you want to resize, move the slider (see Figure 8.1) to the size (resolution) you want the photo to be, and then tap Save.

Figure 8.1 The slider to set resolution in Simple Resize.

You can resize the photo down to a minimum of 120×160 (about 20 KB), or 7.8 percent of its original size.

You also have the option to resize in Photogene after you finish working on a photo.

All you do is:

1. Tap Edit New Photo.
2. Tap the photo you want to resize from your Camera Roll.
3. Tap the last icon (a check inside a square) at the bottom left of the screen.
4. Tap Resolution.
5. Tap one of the following resolutions: 320, 640, 1024, 1600, or 2048.

You have a wide variety of sizes at which to save your photo:

- The 320 means you're saving as 240×320 (about 28 KB).
- The 640 means you're saving as 480×640 (about 80 KB).
- The 1024 means you're saving as 768×1024 (about 185 KB).
- The 1600 means you're saving as 1200×1600 (about 468 KB).
- The 2048 means you're saving as 1536×2048 (about 933 KB).

Resizer, another app that is just for resizing, gives you a choice of three sizes: 320×240, 480×360, and 640×480. To use this app, you tap on its icon on the home screen, which leads you to a blank screen with a double-rectangle icon in the bottom-left corner. Tap this icon to navigate to the Camera Roll, where you choose an image. The image is brought onto the screen with three buttons with the sizes written on them, as you see in Figure 8.2. You choose the size you want, and the image is saved at that size.

Figure 8.2 Resizer gives you a choice of three image sizes.

Cropping and Rotating on the iPhone

Cropping a photo is a world away from resizing one. When you crop, you make the size of your image smaller; however, unlike resizing, the picture becomes totally different. If you want to home in on details of a photo, place a subject at a specific point in the frame, and/or eliminate subjects/objects from a frame, you can crop a photo.

Cropping in Photogene

Photogene not only resizes photos, it also crops and rotates them. In the app, you can crop right after you take a photo, or you can do it by editing new photos in your Camera Roll.

All you do is click on the Scissors icon. When you do, a crop box (as shown in Figure 8.3) will appear. To change the size of the crop, you just touch and drag the crop box. Figure 8.4 shows images of Salvation Mountain near the Salton Sea in California before and after cropping.

Figure 8.3 You can change the crop box to any size you want, and you also have a choice of ratios to set.

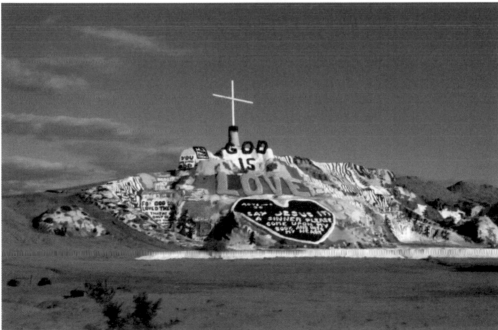

Figure 0.4 Image before and after cropping.

If you touch inside the crop box, you'll see the size of the part of the photo the crop box encloses. The second image in Figure 8.4 shows the Salvation Mountain shot cropped down to 1024×682 pixels.

If you want a certain ratio to your crop box, you have a choice of 1:1, 3:4, 4:3, 9:16, or 3:2.

You can also rotate your photos in Photogene by tapping on the double-arrow icon.

In addition to being able to rotate your photos horizontally, vertically, and 90 degrees in any direction, there is a slider you can use to straighten out your photos, which essentially rotates (and stretches) them by a minimal amount so they appear straight on the screen. Figure 8.5 shows the cropping icons at the bottom of the screen, as well as the Straighten slider. Figure 8.6 shows the image before and after straightening. The image ratio changes a bit after this action, and the resolution drops a bit (even if you choose Original Size as a Save option).

Figure 8.5 Cropping and straightening choices in Photogene.

Figure 8.6 Image before and after straightening.

Cropping with Scissors

Scissors, another cropping app, allows you to crop and rotate any picture in your iPhone in the same action.

Scissors lets you crop any size rectangle in your image. To use Scissors, you tap on the app's home page, where it will ask you to tap to begin. You'll be led to the Camera Roll, where you'll choose an image. Figure 8.7 shows the image chosen for cropping before the crop.

Figure 8.7 Image of Michael Jackson look-alike before cropping.

You'll see your image come up on the screen, as shown in Figure 8.8.

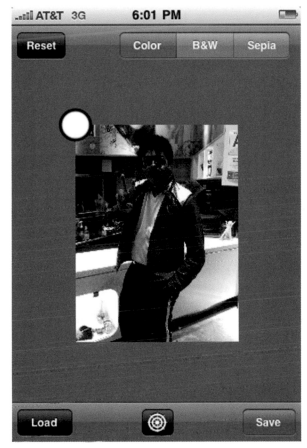

Figure 8.8 Image as seen on the iPhone as it first appears in the Scissors app.

You can make the rectangle any size in the image by touching and dragging the white dot around inside it. You can also make the image bigger by spreading two fingers apart on the screen. To rotate the image, just rotate your two fingers on the screen. You can also tap on the middle button to rotate the image in 45-degree increments.

NOTE

In Scissors, you can't move the rectangle; you can only move the image.

Move the image around so that it is placed where you want it in the rectangle. Figure 8.9 shows how to place an image inside the fixed rectangle in the program.

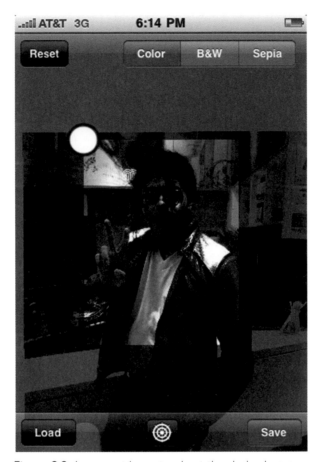

Figure 8.9 Image set in rectangle at the desired crop, ready to be saved.

Figure 8.9 also shows the image stretched and moved into the rectangle, which was shaped to a close-up portrait crop.

Finally, you tap Save. The resulting image is saved into your Camera Roll. Figure 8.10 shows the cropped photo.

Figure 8.10 Photo after crop in the Scissors app.

> **NOTE**
> You can also convert your image to black and white or sepia (and back to color again if you decide you don't like those shades) by tapping the respective buttons at the top-right corner of the cropping screen.

Cropping with PhotoForge

Neither Photogene nor Scissors shows you the result of the crop until after you process it. At that time the cropped photo will appear as the last image in your Camera Roll.

PhotoForge also has a cropping option. This app is unique in that after you crop, you see the cropped image on the screen.

Using PhotoForge's crop is similar to using cropping in the others. You tap on the folders icon (the first icon at the bottom of the screen) and then choose Open (or Camera if you're going to shoot a new photo). Then, in your Camera Roll, you navigate to the photo you want to crop. Next, you just click on the Crop icon, and the (dotted) cropping rectangle will appear. Your image will come up with a dotted rectangle around it. To change the size of the rectangle, just touch and drag one of the corners inward. To move the rectangle around to a different area of the photo, touch and drag from the inside of the rectangle. When you have what you want, tap the Crop button at the upper-right corner of the screen. You'll then see the cropped version of the image. Finally, tap the Save icon to save it.

Cropping with Photoshop Mobile

Last but not least, Photoshop Mobile has extensive cropping capabilities. They are described in Chapter 9, "Post-Processing Apps: Tweaking Photos after the Fact in PS Mobile, Brushes, and CameraBag." To crop, you tap the PS Mobile icon and then you tap Select Photo and choose a photo from your Camera Roll. Then you tap the Crop icon (see Figure 8.11) from the menu bar. There are four options in the Crop menu. Do the following for each selection on the menu bar:

- To crop, grab the handle at the top or the bottom to move the cropping rectangle; move cropping rectangle around by sliding your finger from inside the rectangle.
- To straighten, slide your finger up or down on the screen to rotate arbitrarily.
- To rotate, turn your finger on the screen to rotate 90 and 180 degrees.
- To flip, slide your finger up and down to flip vertically (you probably won't want to do that, because it turns your photo upside down) or side to side to flip horizontally.

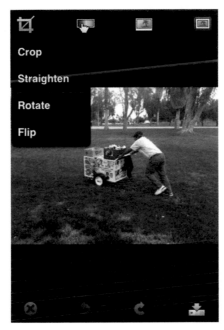

Figure 8.11 In PS Mobile you can crop, straighten, rotate, and/or flip photos.

CROPPING AESTHETICS

You can keep in mind certain rules when you are cropping photos. One thing to keep in mind is the Rule of Thirds. You can crop photos so that they follow the Rule of Thirds to look like those shown in Chapter 3, "Better Photos on an iPhone."

The other thing to keep in mind is that many times the frame will not be filled (as required by rules of composition) with your subject when you take an image with the iPhone camera. This is because of its set focal length. You can't zoom in or out, so you have to do your best by physically moving in and out with the camera to get your picture.

Another issue of concern is aspect ratio. The aspect ratio of the iPhone camera is 4:3, the same as many other point-and-shoot digital cameras. The aspect ratio of dSLR cameras is 3:2. You'll find that many images in this book have an aspect ratio of 3:2 because that is the way the layout is set up. For this reason, many of the images have been cropped from 9:6.75 to 9:6. As a matter of fact, if you're posting to a blog and you want to look professional, your images should have an aspect ratio of 3:2, which means you'll be cropping your iPhone photos if you want to display them in the same way dSLR camera shots are displayed.

(continued)

CROPPING AESTHETICS (continued)

A good example of cropping to the 3:2 aspect ratio at the same time as making the subject sit snugly in the frame is the crop of the tortoise is shown in Figure 8.12. The picture before cropping is at an aspect ratio of 3:4. The after-cropping picture is the smallest possible crop that includes the whole tortoise in the frame at a 3:2 aspect ratio.

Figure 8.12 Tortoise cropped to a 3:2 aspect ratio.

Printing Photos

The best way to print iPhone photos is to download them onto your computer and use your computer to print them in the same way as you would any other photos. Each printer's workflow is different, so you should follow the manual that came with your printer.

The apps that handle printing are available for HP, Canon, and Epson printers. They require that your phone be connected to the Internet via a Wi-Fi connection and that your printer is on the same Wi-Fi connection.

For HP printers, there's iPrint Photo, which is free and works with many HP printers. For the latest directions to use the app on your iPhone and a printer compatibility list, go to www.hp.com/go/iprintphotoforiphone.

For Epson printers, there's Epson iPrint, which only works on a small number of Epson printers:

- Artisan 700
- Artisan 710
- Artisan 800
- Artisan 810
- Epson Stylus NX510
- Epson Stylus NX515
- WorkForce 310
- WorkForce 315
- WorkForce 600
- WorkForce 610
- WorkForce 615

Other printing apps that let you print directly to your printer from the iPhone include iPrintApp ($1.99) and Print ($4.99). Finally, there's iPrintMe, which is a service to which you upload your photos to get them printed on canvas and then sent to you. It's only $39.

Framing Photos

If you're into having frames (or borders) around your photos, there are several apps that do this.

Photogene Borders

The best app for this by far is Photogene. From making your own frame using a varied selection of colors and shapes, to choosing an already made one, Photogene can meet any framing need. If you want to match a frame to your webpage or blog, this is the app to use.

To frame or add a border to your photo, tap on the square icon in the row of icons on the left side of the screen. For a quick frame or border, tap on the Presets icon in the bottom row of icons on the screen. Above the bottom row of icons will be another row of icons with your choices for borders. Figure 8.13 shows that the icon in green is the choice of border selected for the image on the screen. There are 15 choices of borders. To see them all, swipe your finger to the left.

Figure 8.13 The green icon shows the choice for a border for the picture on the screen.

You can also customize your borders. All you do is tap Custom, and Shape will come up in the top row of icons. When you tap Shape, you get a choice of four shapes. After you choose one, a width slider will come up for you to determine the width, and two more icons, Color and Shadow, will come up in the top row of icons. When you tap the Color icon, a pop-up menu of color swatches will come up for you to choose from. When you tap Shadow, a pop-up comes up with different types of shadows to choose from and a Width slider to adjust width. After you

choose a shadow, a Color button will appear in the top row for you to choose the color of the shadow. It's all quite fun. When you're finished, you tap the check (to save) on the bottom row of icons listed vertically on the left side of the screen. In Figure 8.14, I picked a circular border in the color red and an outside shadow in the color red.

Figure 8.14 The Custom Borders option creates a new set of icons you can use to tweak your borders.

The most remarkable option of this app is one of two effects you can produce with a simple tap. Instead of tapping Custom in the bottom row of icons, try tapping Effect. When you do, two icons will appear in the top row. If you tap the one on the left (the first one in the row after the word "Effect"), a reflection will be added under the bottom part of your image, as shown in Figure 8.15. The second icon adds black vignetting around your image.

Figure 8.15 You can make a small reflection at the bottom of your photograph using Photogene.

NOTE

The reflection effect only works if the bottom screen isn't a solid color. You have to have part of your subject or object take up space in the bottom of the screen.

Photoshop Mobile Borders

Photoshop Mobile also offers a set of borders. To get to them, you tap the app's icon and then tap the Select Photo button to choose a photo from your Camera Roll. Then, when your image comes up, you tap the icon in the top-right corner of your screen. (It's the last one in a row of icons.) Select Borders from the menu bar, and a row of borders like those you see in Figure 8.16 comes up. Tap the one you want. In Figure 8.16, film emulsion is selected.

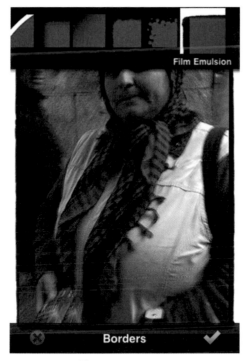

Figure 8.16 The film emulsion border chosen in PS Mobile.

Fun with Imikimi Frames

Finally, there is Frame Photos with Imikimi. This app lets you select a frame from millions of frames made by artists all over the world. The app's directions are simple: Tap Choose a Kimi, Add Photos, and And Share.

Going through the hundreds of frames isn't all that simple, though—you'll spend some time finding a frame you like, just because there are so many and because downloading the frames takes some time.

Here are the steps to making the photo: You swipe through the frames that come up to find one you like. Then tap it, and it will come up full screen. (You can also tap the Customize tab to do this.)

The image then comes up with a place (an icon that is a square with a + sign in its parameter) to tap, which begins the process of uploading your photo from your iPhone into the picture on the screen. Figure 8.17 shows the place where you tap to get your photo. (In this instance, it is the face of the gorilla.)

Figure 8.17 Tap on the prompt icon on the screen to have your photo put in that location.

It will then ask you where you want to get your photo from. Figure 8.18 shows you the options you have for obtaining a photo. (It's kind of cool that you can pick one up at Facebook.)

Figure 8.18 You have a choice of places—online and on the iPhone—from which to get your photo.

You then take the photo or bring it up from any of the choices you have. The photo is displayed on a preview screen if you decide to take one. After you take a photo, you have a choice to retake it or use it by tapping on buttons on the bottom of the screen. (If you decide to bring in one from the Camera Roll, you just choose one from there, and it's placed in the Kimi photo.) Then you have a choice to pan and zoom (which enables you to move the photo around in the embedded Kimi photo), flip, or trash by using the buttons at the top of the screen.

Click Save if you like the image. The Save command saves your image in My Kimis. Figure 8.19 shows the finished photo. It is a low-res photo that can only be used on the web.

Figure 8.19 The finished photo is first saved into the app's photo file, called My Kimi.

There's one more step to save the photo into your Camera Roll. You have to tap the My Kimis icon at the bottom of the screen. You'll see your image there. Tap it and then tap the iPhone option. Finally, tap Save in Photo Library, which saves the image in your Camera Roll.

NOTE

If you're taking the photo, you'll have to take a few shots until it fits in the space properly. There are no editing tools to do this.

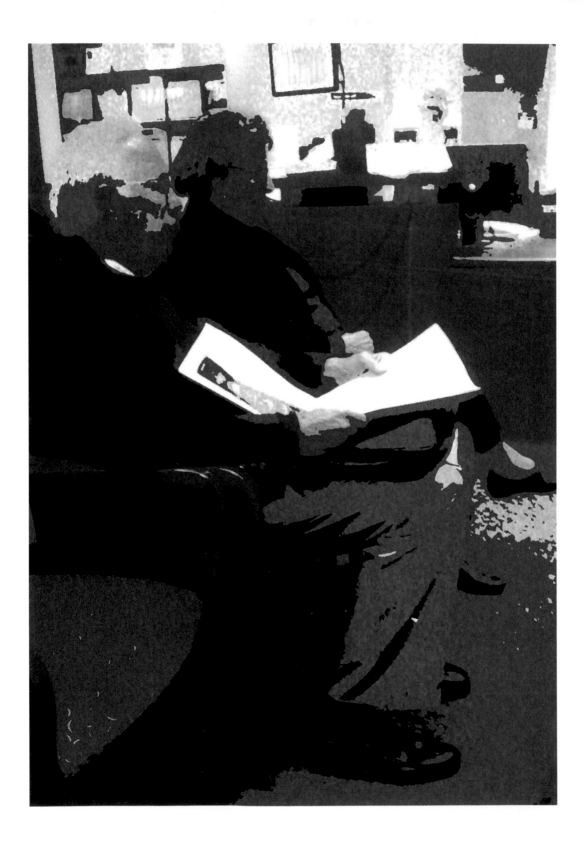

Post-Processing Apps: Tweaking Photos after the Fact in PS Mobile, Brushes, and CameraBag

There are dozens of apps to help you tweak your photos after you've shot them. Some are free and some are not. Some offer sliders that make saturation, contrast, and brightness tweaks, and others offer numerous filters that do everything from dating your photo (making it look like a vintage photograph) to performing umpteen sepia conversions. One—Brushes—will let you color in your photos so that they look as if they could be on the cover of a magazine. (One such work was on the cover of *The New Yorker*.) Here's the skinny on some of them,

Free and Easy PS Mobile

One of the most popular apps out there is the PS Mobile photo-editing app. You can't beat the price on this one, because it's free. In Chapter 5 we discussed the Sketch option in a sidebar. The nice thing about running a photo through PS Mobile is that it comes out at the same resolution after saving as you started with, unlike most other apps, which lower the resolution of the saved photo that you tweaked.

Figure 9.1 A photo tweaked with the Sketch, Sharpen, Exposure, Saturation, and Contrast options in PS Mobile.

To use the program, tap on the app's icon. You'll then be asked to either Select Photo or Take Photo. If you tap Select Photo, you'll be taken to your Camera Roll, where you can choose a photo.

Your photo will be put on a screen with icons for the different tools in a row at the top of the screen. For each icon (see Figure 9.2), there are drop-down menus. The following subsections describe the icons along with the drop-down menu options and how to use each one.

Figure 9.2 Each icon at the top has a drop-down menu of options.

Crop Icon

You can crop, straighten, rotate, or flip your image by selecting the option from the drop-down menu. For detailed directions on how to do this, refer to Chapter 8.

Gradient Icon

The menu options for this icon are:

- **Exposure.** Slide your finger (or tap) right across the screen to increase the exposure; slide left to decrease it. Values from −100 to 100 are displayed at the top of the screen.

- **Saturation.** Slide your finger (or tap) right across the screen to increase the saturation; slide left to decrease it. Values from −100 to 100 are displayed at the top of the screen.

- **Tint.** With this option, the image changes to sepia tones. Slide your finger (or tap) right or left to change the frame tint color to the color indicated on the color strip at the top of the screen.

- **Black & White.** This option changes the photo to black and white.

- **Contrast.** Slide your finger (or tap) right across the screen to increase contrast; slide left to decrease it. Values from −100 to 100 are displayed at the top of the screen.

Palm Tree Icon

The menu options for this icon are:

- **Sketch.** This option makes the image look like a sketch. Slide your finger (or tap) right across the screen to increase the Sketch value; slide left to decrease it. Values from 0 to 42 are displayed at the top of the screen.

- **Soft Focus.** This option blurs the image. Slide your finger (or tap) right across the screen to increase the soft focus; slide left to decrease it. Values from 0 to 42 are displayed at the top of the screen.

- **Sharpen.** This option sharpens the image. Slide your finger (or tap) right across the screen to increase the sharpness; slide left to decrease it. Values from 0 to 42 are displayed at the top of the screen.

Border Icon

The menu options for this icon are:

- **Effects.** Tap the Golden Gate Bridge icon to choose from the following effects: Vibrant, Pop, Vignette Blur, Warm Vintage, Rainbow, White Glow, Soft Black & White. Figure 9.3 shows the location of the icons for different effects with the Vibrant effect chosen.

- **Borders.** For information about borders, see the Chapter 8.

After you're finished editing, you tap the green checkmark at the bottom of the screen. If you don't like what you've done, you can clear the screen by tapping the red X. Once you tap the green checkmark, you're taken back to the editing screen, where you can do the following things with the icons on the bottom of the screen. The red circle with an X in it is to exit editing, the left-pointing red arrow is to undo, the right-pointing green arrow is to redo, and the green down arrow is to either Save and Exit or Save and Upload.

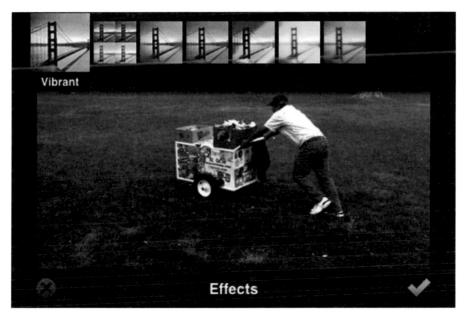

Figure 9.3 PS Mobile has seven special effects from which you can choose.

Paint Your Way to Fame with Brushes

The Brushes app has become so well known because it was used to make the cover of the June 2009 *New Yorker* scream with color.

Although the app is notable in the features it provides, it does have some limitations—the biggest being that it does not have a feature to select and then cut and paste parts of your image into other parts. Not having this feature means this app requires touch-painting skills that you can learn by following the upcoming directions. Although the directions might seem cumbersome, once you get the idea, you can zoom through painting on top of photos in a flash (well, maybe not a flash, but in a half hour or so).

> **NOTE**
> At brushesapp.com, you can download the user's guide to the app. .

Here are some detailed directions to get you started using Brushes.

When you tap the icon for the program, you are taken to the Gallery of Images. You'll find some sample images there that have been tweaked using the program. If you've already worked on some images, those will be included too. Figure 9.4 shows what the Gallery looks like.

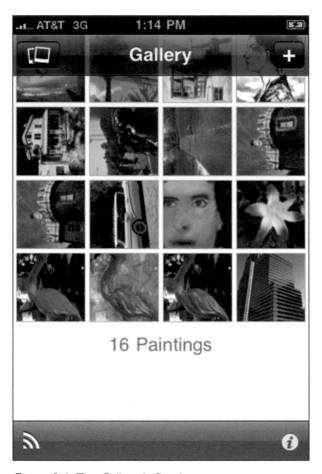

Figure 9.4 The Gallery in Brushes.

To view a photo in the Gallery, tap it. The photo will appear full-screen in Viewing mode (see Figure 9.5).

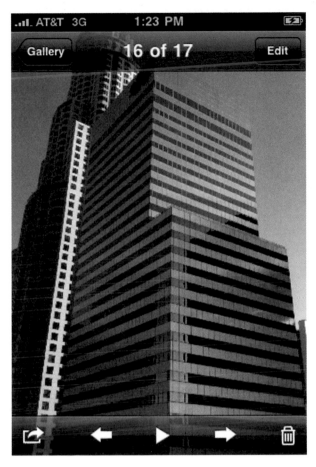

Figure 9.5 Viewing mode in Brushes.

There are several icons at the bottom of the screen in Viewing mode.

- ■ Tap the arrow inside the rectangle (the leftmost icon), and a pop-up menu will appear, giving you the following choices: Duplicate Painting, Add to Photos, Email Painting. When you tap on Add to Photos, it saves the image into your Camera Roll.

- ■ Tap the left-pointing arrow, and you're taken to the previous photo in your Gallery. Tap the right-pointing arrow, and you're taken to the next image in your Gallery.

- ■ Tap the big arrow in the middle, and a slideshow will start that runs from the image you are on to the last one in the Gallery.

- ■ Tap the trash can icon to delete a photo.

NOTE

If there are no icons on a page, tap the screen to bring them up.

NOTE

You should make a duplicate after you bring your image into the app. Then, if you mess up and want to go back to the original, all you have to do is go back to the Gallery and tap on the duplicate copy you made. To make a duplicate, tap the arrow inside the rectangle (the leftmost icon) in Viewing mode, and a pop-up menu will appear. Tap Duplicate Painting, and your image will appear as a duplicate in the Gallery.

If you tap the Edit button at the top-right of the screen in Viewing mode, you'll be brought to Painting mode. To get back to Viewing mode, tap Done.

If you don't want to use a photo in the Gallery, and you want to start working on a new image, tap the double-rectangle icon in the Gallery. Choose a photo from your Camera Roll, and it will automatically show up on the screen in Painting mode.

The tools in Painting mode are as follows. They are shown in Figure 9.6.

- Tap the lines icon to activate the Layers panel. (The Layers panel is detailed later in this section.)
- Tap the paintbrush icon to activate the Paintbrush. (The Paintbrush panel is detailed later in this section.)
- Tap the curlicue to the left icon to undo an action.
- Tap the curlicue to the right icon to redo an action.
- Tap the Eyedropper tool to pick up a color from any area of the image. (The Eyedropper tool is detailed later in this section.)
- Tap the square icon to choose a paint color from the Color Picker. The Color Picker is detailed later in this section.

Figure 9.6 In Painting mode, there are several tools to work with.

NOTE

To effectively paint a picture, you have to zoom into it. To zoom, spread your fingers apart on the screen. To move the image around, slide two fingers on the screen. To go back to 100-percent zoom level, double-tap on the screen.

So what are the details for each of the options in Painting mode? Undo and Redo are easy. All you do is tap the curlicue to the left icon to undo your last action, tap it again to undo the action before that, and so on. The Redo function brings back the action.

I'll describe the rest of the tools one by one as they are displayed in Painting mode: Layers, Paintbrush, Eyedropper, and Color Picker.

Layers

The Layers panel has six icons at the bottom of the screen (see Figure 9.7). Starting from the left, the paint can icon allows you to paint the layer you are working on with a color. The down arrow is used to merge the layer you are working on with the one below it. The curlicue to the left is to undo an action, and the curlicue to the right is to redo an action. The trash can is to delete the layer you are working on, and the plus sign is to add a new transparent layer.

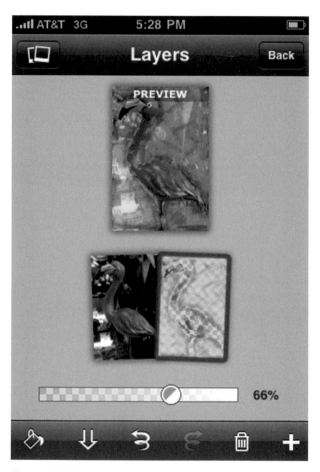

Figure 9.7 The Layers panel in Brushes has six icons.

You can switch the two layers at the bottom by sliding your finger over them.

When you bring in a photograph from your Camera Roll, the Layers panel will look like what you see in Figure 9.8.

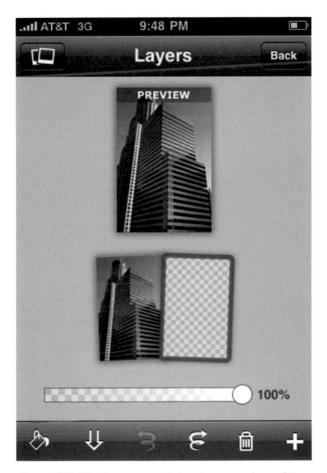

Figure 9.8 The Layers panel showing a preview of the image, the image in a layer, and a transparent layer.

To select a layer to work on, you tap it, and a blue border will appear around it. To trash it, tap the trash can icon. To bring in a new transparent layer, tap the plus sign.

If you're going to color something in, it's best to color on a transparent layer, because you can delete it if it's bad. To color on a transparent layer, all you do is double-tap it on the Layers panel.

Take, for example, the image in Figure 9.9. I thought that might be a good photo to convert to this new Brushes media, so I went to work. I double-tapped the transparent layer and colored in the background yellow with an Impressionist brush. It looked too flat, so I tried lowering the opacity of the colored-in layer in the Layers panel. This caused a little of what was there for the background in the original photo to meld in with the yellow, producing the image you see in Figure 9.10.

Figure 9.9 Photo before playing around with Brushes.

Figure 9.10 Photo after playing around with Brushes.

To save the image, merge your layers by tapping the down arrow icon, then tap the Back button, and then tap Done. (This will put you in Viewing mode.) Then tap the rectangle with the arrow on it. Finally, tap Add to Photos and then Export.

> **NOTE**
>
> After you export your photo to your Camera Roll, you'll find that you've produced a low-resolution photo. No worries—you can increase the resolution in Photoshop with this kind of media to get a fairly good-quality high-res photo.

Paintbrush (and Eraser)

The Brush panel is actually two tools—a paintbrush and an eraser. You just tap the icon for either to select it. You'll see a selection of brushes—you can either tap the one you want or stroke to one. There are sliders to adjust the brush (eraser) spacing, the brush (eraser) size, and the opacity (or the eraser transparency). The top of the panel shows the resulting brush stroke from the choices you make. Figure 9.11 shows each of these options.

Figure 9.11 The Brush and Eraser panel in Brushes.

Eyedropper

The Eyedropper lets you choose for the brush any color that exists in your frame. After you tap it, a circle will show up with a cross in the middle. The center of the cross is the location in the frame where the color is being picked up. To move the circle, just drag it around the frame. When you do, you'll see the color vary as a result of moving over the different colors of your image. As soon as you lift your finger off of the circle, it will vanish, and you'll be left with the color of the last spot where it was located. You can get it back anywhere in your frame by touching the screen for half a second. Figure 9.12 shows the circle that appears after you tap the Eyedropper icon. The pink inside the circle is representative of the color in the image where the center of the cross is.

Figure 9.12 The Eyedropper lets you change the color of the brush to one of the colors in your image.

Color Picker

Figure 9.13 shows the contents of the Color Picker panel. The large circle in the Color Picker allows you to change the hue and saturation of the brush. The slider below can be used to adjust the brightness of the color, and the opacity slider below that changes the opacity of the color.

Figure 9.13 You can change the color of your brush using the Color Picker.

N O T E
Sometimes the slider won't move when you drag it. When this happens, all you have to do is tap inside the rectangle of the slider.

N O T E
If you use a color that has some transparency, the color you are painting over will be mixed with the new color to create a different color.

QUICKIE WAYS TO USE THE TOOLS IN BRUSHES

Here are some quick ways to change the tools while you are working in Brushes.

- Double-tap the bottom left to undo.
- Double-tap the bottom right to redo.
- Double-tap the upper left to toggle between the brush and the eraser.
- Double-tap the upper right to adjust the brush size.
- To use the Eyedropper tool, tap and hold while painting.
- Tap and hold on a layer to activate Copy and Paste.

CameraBag Belts Out the Filters

In 2009, a *New York Times* article said, "If you buy just one filter app, make it CameraBag." The effects produced by applying the filters in CameraBag are nothing less than spectacular.

CameraBag is a filter application that gives you a choice of filters through which you can run your photos to give them a distinct effect. The effects are Helga, Lolo, Instant, Mono, 1974, Infrared, Colorcross, Magazine, Silver, 1962, Cinema, and Fisheye. The app not only changes the color and light in your image, it also changes the image's shape. Some filters will convert your image to a square reminiscent of the 1950s Kodak days of film photography. Some filters will add a white border to your photo. Do keep in mind, though, that after processing with the filter, the resolution is taken down a bit.

To use the program, tap its icon. You'll be taken to the screen shown in Figure 9.14. You have a choice of four options.

- Tap the camera icon to take a picture with the effect.
- Tap the envelope icon to send the picture. (This only works if you have a picture on the screen.)
- Tap the disk icon to save your image onto the Camera Roll. (This only works if you have a picture on the screen.)
- Tap the double square to get a photo from the Camera Roll.

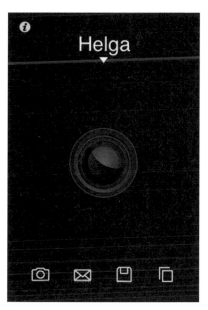

Figure 9.14 The screen that comes up after you tap the CameraBag app on your iPhone.

If you tap the word Helga (a type of filter), you'll be taken to a screen that lists all the filters available in the app. Figure 9.15 shows them listed.

Figure 9.15 A list of available filters in the CameraBag app.

Now, if you tap one of those filter names—say, 1974—you'll be taken to a blank screen with 1974 written on the top and the above-named icons on the bottom. To bring in a picture, tap the double squares at the bottom right of the screen. From there, you're taken to your Camera Roll, where you can select a picture. The picture will come up after it's processed with the filter you have chosen (1974, in this case). Figure 9.16 shows an image of Gene Autry converted with the 1974 filter using the app.

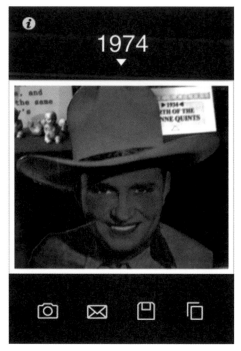

Figure 9.16 An image processed with the 1974 filter.

To save the image, you just tap the disk icon.

Following are examples of what each filter does.

The Helga filter offers color fading and vignetting. The vignetting you get is the same as you would get if you took the photo with a fisheye lens. Figure 9.17 shows a photo of a baby before being tweaked with the Helga filter. Figure 9.18 shows the photo after the tweak. You can see how the proportions changed in the later figure.

Figure 9.17 Photo before being tweaked using the Helga filter.

Figure 9.18 Photo after being tweaked with the Helga filter.

The Infrared filter simulates an infrared filter that you would put on your camera. The effect produces a glowing black-and-white image. The proportion of the image is not changed. Figures 9.19 and 9.20 show a picture before and after tweaking using the Infrared filter.

Figure 9.19 Photo before being tweaked using the Infrared filter.

Figure 9.20 You get a black-and-white glowing photo after using the Infrared filter.

If you want to increase your color saturation and contrast as well as make your photo square, then the Lolo filter is for you. Be aware that this filter takes your resolution down quite a bit. It's definitely not an image you're going to want to blow up. Figures 9.21 and 9.22 show a picture before and after tweaking using the Lolo filter.

Figure 9.21 Photo before applying the Lolo filter.

Figure 9.22 The Lolo filter enhances color saturation and contrast.

I find that the Magazine filter makes the photo look as if it was taken straight from an old issue of *Life*. The tweaked image shown in Figure 9.24 (Figure 9.23 shows the image before tweaking) was very well received when I posted it to Facebook and Twitter—although no one realized that Cadillac made station wagons. Everyone who commented on the picture agreed that it was a Buick when really it wasn't!

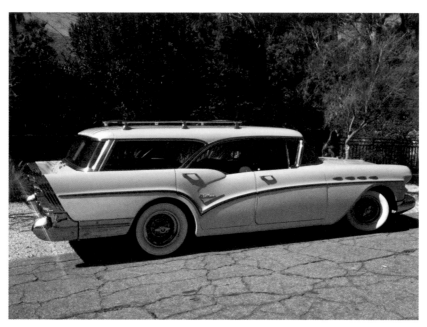

Figure 9.23 An old Cadillac station wagon before tweaking.

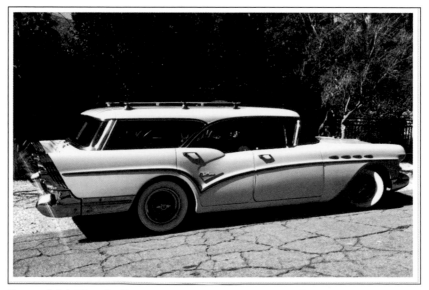

Figure 9.24 The Cadillac tweaked using the Magazine filter.

Fans of the bleached-out Polaroid colors that can be had with an old Polaroid Instamatic camera will be happy, because the effect is easy to get with CameraBag's Instant effect. Figure 9.25 shows a truck with snow on it before tweaking in CameraBag. Figure 9.26 shows that even the shape and the white space fit the original Polaroid style to the shot.

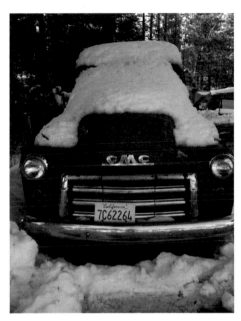

Figure 9.25 A truck with snow on it before tweaking.

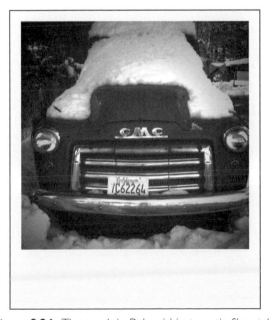

Figure 9.26 The truck in Polaroid instamatic film style.

What's nice about the 1974 filter is that, indeed, it makes your photos look as if they were shot during that year. It helps if you have some old, retro subject matter in your original photograph, like the old doll heads shown in Figure 9.27. The after-tweaks image in Figure 9.28 not only looks as if it were shot in the '70s, but its weirdness (doll heads in a cage) will earn the photo an extended gaze.

Figure 9.27 A storefront window display before tweaking to 1974.

Figure 9.28 Retro look to doll heads after tweaking with the 1974 filter.

If you want some cool blue tones added to everything in your frame, then the Colorcross filter is for you. Although the dog doesn't look especially cold in Figure 9.30, the pool sure does. Figure 9.29 shows the dog in the pool before the tweak.

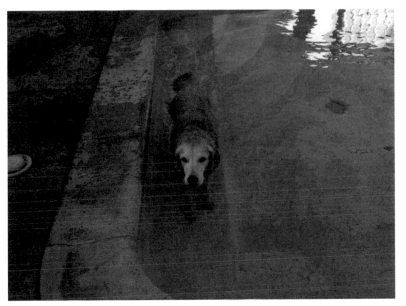

Figure 9.29 Image of a dog in a pool before applying the Colorcross filter.

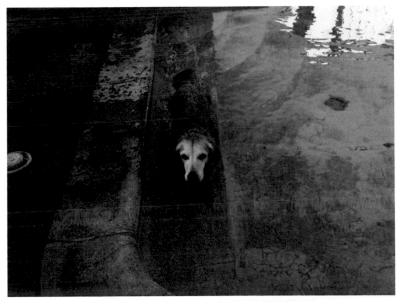

Figure 9.30 The image of the dog after applying the filter shows enhanced blue tones.

Although there are many more apps that turn photos to black and white, the Mono filter not only does that, but it also adds a white border and trims down the resolution for easy emailing. The black-and-white conversion that is a result of this filter doesn't lose sharpness and has nice gray tonal ranges, as shown in Figure 9.32. (Figure 9.31 shows the image before the tweak.)

Figure 9.31 Image before applying the Mono filter.

Figure 9.32 The Mono filter turns images to black and white.

Cinema has to be my favorite filter. You can't do better at getting a cinematic look to your photos in a wide-screen format than by using this CameraBag filter. Figure 9.34 shows that while the dogs don't appear to be any bigger using this filter, the faded image looks bigger because of its display in wide-screen format. Figure 9.33 shows the image before the tweak, and Figure 9.34 shows it after.

Figure 9.33 The image before tweaking with the Cinema filter.

Figure 9.34 The Cinema filter gives you a wide-screen view.

Although the 1962 filter tends to blow highlights and darken blacks, it does give a retro pre-hippie feel to the image. Figure 9.36 shows some guys hanging out in Park Güell in Barcelona—it looks like it could be 1962. Figure 9.35 shows the image before the tweak.

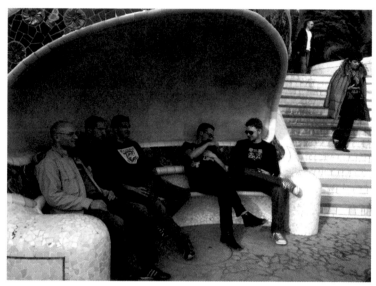

Figure 9.35 The image before being taken back to 1962.

Figure 9.36 Retro black and white for a '60s look.

The Silver filter brings a certain glamour to some shots. The outfit in Figure 9.38 appears more glamorous than it does in color (Figure 9.37). The silver tint lets you focus more on the rhinestones.

Figure 9.37 Image before the Silver filter application.

Figure 9.38 The Silver filter makes this stand-alone outfit even more dazzling.

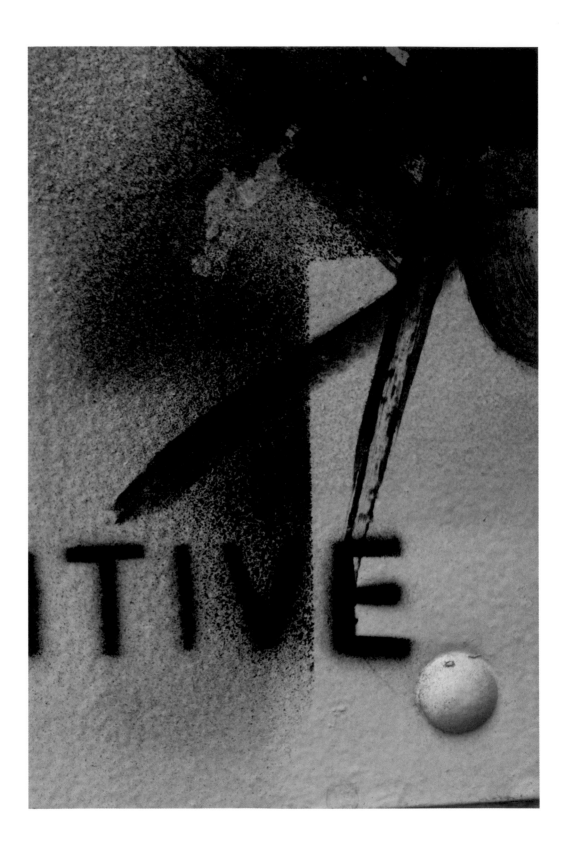

Post-Processing Apps: Tweaking Photos after the Fact in PhotoForge, ColorSplash, FX Photo Studio, and Photo fx

The apps for the iPhone will have you being creative beyond your wildest dreams with your photography. It's amazing that you can create works of art with your fingers, and that you can do it anywhere. This chapter covers four more dynamite apps—PhotoForge, ColorSpash, Photo Studio, and Photo fx. You'll find everything you need to use these apps, including a detailed list of the options to assist you in navigating through them

PhotoForge

In the section "Cropping with PhotoForge" in Chapter 8, a detailed discussion presented the ins and outs of cropping. There are many more options in PhotoForge that you can use, including a choice of 15 adjustments and 18 effects. You could spend all day playing around with your images with this app.

Indeed, I did spend all day making the fire truck picture from a photograph that you see in Figure 10.1.

Figure 10.1 Fire truck before and after using PhotoForge tools.

You can set PhotoForge's output files to full resolution, but it's a bit tricky, because you can't do it from the app itself. There is no access to the settings when you are working in the app. To get to the settings that include access to change the resolution, you can tap Settings on your iPhone's home screen and swipe downward until you get to the PhotoForge listing. Tap it, and you're taken to the app's settings, shown in Figure 10.2. Tap on Max. Output Resolution to be taken to a list of resolutions. You can choose from 640, 800, 1024, 1600, and Max. Figure 10.2 shows how the choices are displayed on the screen with Max. Output Resolution selected. To select a resolution, you just tap it.

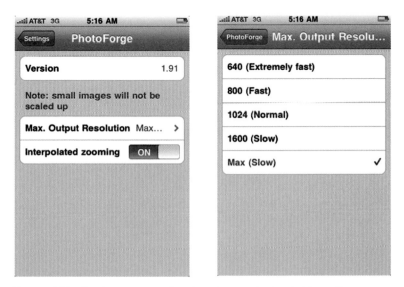

Figure 10.2 Settings screens for changing resolution in PhotoForge.

In PhotoForge, you can start out by opening an existing photo, creating a new blank slate upon which to draw, or taking a picture with the camera. (See the description for the Folder icon later in this chapter.)

PhotoForge has many options, as you can see in Figure 10.3.

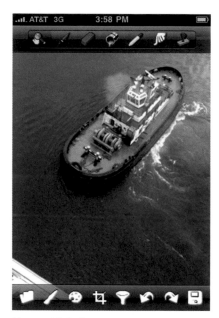

Figure 10.3 PhotoForge has an extensive menu of options at the top and bottom of the screen.

On the top, going from left to right, you have the following icons.

- **Magnifying Glass.** The Magnifying Glass makes your image moveable. You can spread two fingers apart on the screen to magnify the image. You can use one finger to move it around. When you're working, you move back and forth from this option to others so you can work with the image at different magnifications.

- **Paintbrush.** When you tap on the Paintbrush icon, you're put in Paintbrush mode. Every time you touch, tap, or slide your finger on the screen, you'll apply paint marks on the screen. The White Paintbrush and Palette at the bottom of the screen control can be applied to this function. They are described in a moment.

- **Eraser.** When you tap on the Eraser, it is activated, but it will only erase marks that you've made with another tool (the Paintbrush or Paint Can). It will not erase any part of your original image.

- **Paint Can (Fill tool).** The Paint Can will color in the entire frame. For it to work, you must swipe your finger across the screen. It acts like a filter you'd put on your camera lens or like the filter you can apply in Photoshop. You can change color and transparency using the Palette option in the bottom row, which is discussed in a moment.

■ **Eyedropper.** You can use this tool to pick up a color you already have on your screen. After you tap it, move your finger around the screen. You'll see a ring come up that changes color as you move your finger across the screen. When you see the color you want, lift your finger off the screen to have the paint palette set to that color. Figure 10.4 shows the Eyedropper's ring, which has picked up dark red from the fire engine.

Figure 10.4 The Eyedropper lets you pick a color that's contained in your image.

■ **Finger (Smudge tool).** The Smudge tool smudges any area of your image that your finger slides over.

■ **Clone Stamp.** To copy one part of your image to another part, you first drag the target icon (shown in Figure 10.5) to the target area that you want to copy. Then you slide your finger back and forth over a new area where you want the target area copied. You can move the target icon by swiping your finger from it to anywhere on the screen.

Figure 10.5 The target icon shows the target area you want to copy.

On the bottom, from left to right, you have the following icons:

■ **Folder.** This option lets you do one of three things, as shown in Figure 10.6.

Figure 10.6 Options for creating a new image.

■ **Open.** You can open a photo after tapping this option. You're taken to the Camera Roll, where you can choose a picture you have already taken.

■ **New.** You can create a new image on a blank slate that comes up after tapping New.

■ **Camera.** After you tap Camera, you can take a picture when the shutter comes up. You'll then get a preview with two options: one to Retake and one to Use. If you like the picture you took, tap Use. The image you took will then appear with the PhotoForge options.

■ **Paintbrush.** You can change the Paintbrush size and type (see Figure 10.7) if you tap the Paintbrush icon in the bottom row of icons. You do this to paint when you are in Paint mode (which you get to by tapping the Paintbrush in the top row).

Figure 10.7 You can change the size and type of paintbrush you use.

■ **Paint Palette.** The Paint Palette icon lets you choose a color and paint transparency (see Figure 10.8) not only for your brush, but also for the Paint Can (Fill tool). Remember that the Fill tool will affect your entire frame, not any one part of your image.

Figure 10.8 You can change the color and transparency of both the Paintbrush and Paint Can with the Palette.

- **Crop tool.** See the "Cropping and Rotating on the iPhone" section in Chapter 8.

- **Filters (T icon).** This is the part of PhotoForge that packs in a plethora of options. They include Adjustments and Effects (see Figure 10.9; you need to swipe your finger up on the screen to view them all). The Adjustments are Curves, Levels, Noise Reduction, Unsharpen Mask, Sharpen, Blur, Simulated HDR, Hue/Saturation, Brightness/Contrast, Exposure, Vibrance, Tilt Shift, Auto White Balance, Auto Exposure, and Auto Enhance. The Effects are Dreamy, Vignette, Lomo, Sin City, Posterize, Watercolor, Oil Painting, Sepia, Black and White, Night Vision, Heat Map, Pencil, Neon, Emboss, Negative, Sunset, BlueSky, and Television. All of the adjustments involve another screen in which you have additional options for tweaking. The effects are automatically activated when you tap them, except for the ones that have an ellipsis next to them. The ellipses indicate that there are additional options for tweaking shown on a pop-up screen.

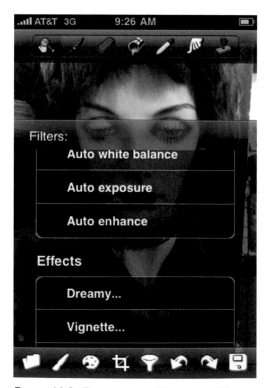

Figure 10.9 To see all the Filters and Effects, swipe your finger upward after tapping on the T icon.

Some of the adjustments offer one slider to tweak your image and are pretty self-explanatory. They are Noise Reduction, Sharpen, Blur, Exposure, and Vibrance. Noise Reduction reduces the tiny dots that are seen mostly in night images. The Sharpen

option sharpens your photo. Blur lets you create differing amounts of softness in your photo by moving the slider to the right. Exposure basically darkens your photos if you move the slider to the left and lightens your photo if you move it to the right. Vibrance makes your colors more vibrant.

There are three auto adjustments: Auto White Balance, Auto Exposure, and Auto Enhance. There are a few moments of processing time after you've tapped on one of them.

A few of the adjustments are more complex. They are explained in the following list.

- **Curves.** If you know Photoshop, the curves work in a very similar way to how they do in that program. If you don't have Photoshop, this is still a fairly simple option. All you have to do when you tap this option on the menu is tap to create a curve point and then slide your finger to change the orientation of the line. You can add as many points as you want—but don't add too many, because the whole thing will get too complicated. You can also tweak by color, opting for All (the default), Red, Green, or Blue. You can also change the color spaces to CMYK or CIE Lab. For the purposes of this book, though, stick with RGB—that is what is used for most purposes. Figure 10.10 shows a tweak of the curves that makes a tonal red solid.

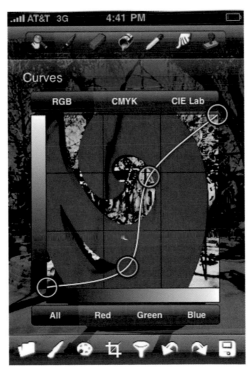

Figure 10.10 You can tweak curves for different kinds of effects.

■ **Levels.** The Levels option (see Figure 10.11) also works the same way as it does
in Photoshop. You can use the sliders (slide your finger using the small triangles
at the bottom horizontal axis of the levels graph) to tweak your image. Slide the
middle or right-end triangle to the left, and the image darkens. Slide the mid-
dle or left-end triangle to the right, and the image darkens. I recommend that
you only work with the middle slider, because moving the end ones will lessen
the number of color tones you will be working with.

Figure 10.11 Tweaking the levels helps you to
produce an image with better contrast and tones.

- **Unsharpen Mask.** Unsharpen Mask (see Figure 10.12) is a sharpening tool with three parameters that can be tweaked using sliders: Amount, Radius, and Threshold. The Amount controls how much darker or lighter the edges of the image become. The Radius controls how much of the edge of the image will be affected. The Threshold controls which edges are tweaked. Low values will sharpen both low- and high-contrast areas. Higher values will sharpen only high-contrast areas.

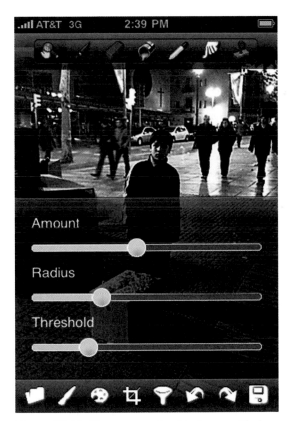

Figure 10.12 You can use the Unsharpen Mask sliders to sharpen your photo.

■ **Simulated HDR.** HDR stands for *High Dynamic Range.* It's the latest trend in photography. Basically, it gives you a much better tonal range of colors in your photo. In PhotoForge, there are two sliders: Shadow and Highlight. Moving either to the right mutes the tones, causing them to change to a more basic form of the color. For example, dark red becomes a vibrant red after the tweak. Be careful not to overdo this one, because if you tweak too much, you'll get blown colors in some of your image. Figure 10.13 shows a landscape before and after tweaking both the shadow and the highlight using the Simulated HDR.

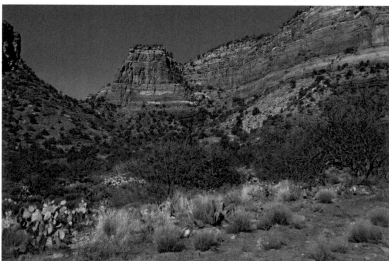

Figure 10.13 Before and after tweaks with Simulated HDR.

■ **Hue/Saturation.** No image-processing program would be complete without a tweak for hue and saturation. PhotoForge offers both of those and a lightness tweak when you tap on the Hue/Saturation option. Figure 10.14 shows the pop-up menu with the three sliders that appear after you tap the Hue/Saturation option.

Figure 10.14 You can tweak hue, saturation, and lightness in PhotoForge.

■ **Tilt Shift.** This is one compelling effect. It's a bit tricky, though. All you have to remember is that when you swipe the slider to the right, the area that's in focus moves down. When you increase the radius, more of the image comes into focus. Figure 10.15 shows a sample tweak where the Location (of the sharp area of the image) is toward the top and where the Radius is set so that the sharp area is wide enough to keep the statue of the soldier's head and chest sharp.

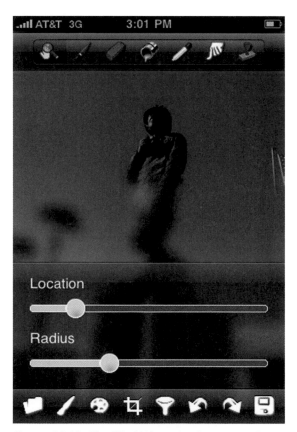

Figure 10.15 The Tilt Shift option lets you soften all but one part of your photo.

PhotoForge has 18 effects. Here is the list, including the tweaking features of each. (If the option on the screen is listed with an ellipsis after it, it means that there is a tweaking option.) Some of the effects are great, and others are not so great. I included a before-and-after image with the effect if I thought it was particularly compelling.

- **Dreamy.** Has a Strength slider.
- **Vignette.** Has a Strength slider.
- **Lomo.** No sliders; automatic tweak. See Figure 10.16.

Figure 10.16 Photo of California poppies (the state flower of California) before and after the Lomo effect tweak.

- **Sin City.** Has a Strength slider.
- **Posterize.** Has a Strength slider.
- **Watercolor.** Has a Strength slider.
- **Oil Painting.** Has a Strength slider. See Figure 10.17.

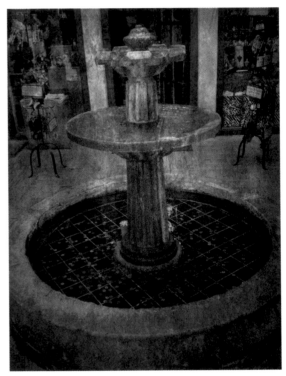

Figure 10.17 Photo of fountain in Sedona, Arizona before and after tweak with the Oil Painting effect.

- **Sepia.** No sliders; automatic tweak.
- **Black and White.** No sliders; automatic tweak.
- **Night Vision.** No sliders; automatic tweak.
- **Heat Map.** Heatmap Type slider. (As you swipe the slider to the right, color combinations of the image change. See Figure 10.18.)
- **Pencil.** No sliders; automatic tweak. See Figure 10.19.
- **Neon.** No sliders; automatic tweak.

Figure 10.18 Photo of feet before and after tweaks with the Heat Map effect.

Figure 10.19 Tweaked before-and-after photos using the Pencil effect.

- ■ **Emboss.** No sliders; automatic tweak.

- ■ **Negative.** No sliders; automatic tweak.

- ■ **Sunset.** No sliders; automatic tweak.

- ■ **BlueSky.** No sliders; automatic tweak.

- ■ **Television.** No sliders; automatic tweak. Tweak is simply light-gray horizontal lines across your image.

ColorSplash

The first thing ColorSplash does is ask you to choose a photo. There are two options: Take Photo or Load Image.

If you opt to take a photo, your camera's shutter will appear. After you tap it to take a picture, a preview of it will appear on the screen. At that point there will be two buttons: Retake and Use. You can either retake the image or use it.

If you opt to use the image by tapping on Use, a prompt will ask you whether you want to save the photo at full resolution before you begin working on it. The options here are Save Photo or Don't Save.

If you opt to load an image, you'll be taken to your Camera Roll, where you can pick one of your images to use in the app.

Next, ColorSplash automatically converts your photo to black and white on a home screen that looks like the one shown in Figure 10.20.

The icons are laid out at the top and bottom of the screen. To get the color back in your image, you just paint the screen with one finger. Use two fingers to zoom in or to move the image around. Tap two fingers on the screen to return the image to its original size (the size of the iPhone screen).

The following subsections discuss what the top icons do.

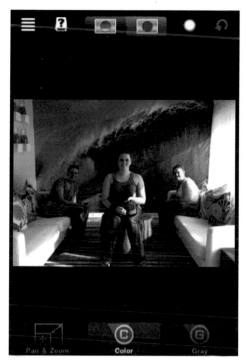

Figure 10.20 The moment your photo enters the ColorSplash home screen, it is converted to black and white.

Menu Icon (Horizontal Lines)

Tapping the Menu icon (which looks like four horizontal lines) gives you options for loading, saving, and inverting your images, as well as access to the settings (see Figure 10.21).

The first set of options on the screen includes Save Image, Save Session, Load Session, and Share/Send Image.

When you tap Save Session, your session will be listed in the Load Session screen. Figure 10.22 shows several saved sessions. When you tap one of the sessions, you'll be taken to a preview screen of it. You have to tap the Load Session button at the bottom of the screen to load it again

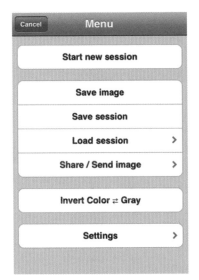

Figure 10.21 Options for the Menu icon. If you don't like what you've done with an existing image, you can tap the Start New Session button.

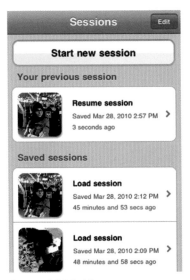

Figure 10.22 You can save a session that you've worked on and access it in the Load Session option.

> **NOTE**
>
> If you save your sessions right away, you won't have to hunt again for the image you've chosen, because you will have loaded it and saved it already.

The Share/Send Image option lets you email your image, giving you a choice of sending your tweaked image at full resolution or choosing from six scaled-down resolutions.

After you tap on a resolution, you'll get a screen with the email already written up and the picture attached. All you have to do is fill in the To and Subject lines.

You also have options to Copy to Clipboard as well as Upload to Facebook, Upload to Flickr, and Post to Twitter.

The next option in the menu is Invert Color to Gray. This option enables you to change anything that's gray (black and white) on your screen to color and anything that's in color to gray. You can change it back to what you had by tapping the Menu icon and then tapping the Invert Color to Gray option again.

Help Icon (Question Mark)

When you tap the Help icon (which looks like a question mark), you're taken to a screen with a series of help videos. They're filled with info, and I recommend that you watch them—they are very well done.

Color View Mode Icon

There are two modes in which you can color: the Red View mode (discussed in a moment) and the Color View mode. Color View mode lets you see the image as it is with both color and gray tones that you have created by painting with your finger.

> **NOTE**
>
> While painting with your finger, you can enlarge and move the picture around with two fingers. Enlarge by moving your thumb and index finger apart and reduce by moving them together. Move the picture around by moving both your thumb and index finger on the screen.

Red View Mode Icon

Use the Red View mode to see what areas of the image you've added color back to. Figure 10.23 shows an example of the Red view. All of the area brought back to color by painting with a finger is in red, as shown. You can use Red view to add color to your image in the same way as you'd use it in Color view. The only difference is that you won't be able to see the color reappear. To see it, you have to tap on the Color View icon.

Figure 10.23 The Red View mode shows the areas you have turned to color.

Brush Icon

A drop-down menu of four brushes appears after you tap the Brush icon. At the top are soft- and hard-edged opaque brushes, and at the bottom are soft- and hard-edged transparent brushes. Figure 10.24 shows the brushes as they appear on the screen after you tap on the Brush icon.

Figure 10.24 There are four brushes in ColorSplash.

There are also three icons at the bottom of ColorSplash. The following subsections describe what they do.

Pan & Zoom Icon

Tap the Pan & Zoom icon if you don't want to risk painting your photos accidentally when you are panning and/or zooming with two fingers in Color mode. (Color Mode is discussed in the following subsection.)

Color Icon

This option is automatically selected when you first load an image into the app. Color mode allows you to paint back the color on the black-and-white photo that appears on your screen when you first load your image.

Gray Icon

After tapping this icon, you can take away the color you've brought back into your image. Essentially, when you paint in this mode, it makes anything in color on the screen gray.

A finished image in ColorSplash can be quite compelling, especially if you want to bring out elements of the photo amidst a black-and-white background. You can see how the items for sale in Figure 10.25 are emphasized by having them in color against a black-and-white background.

Figure 10.25 Photo before and after tweaking with ColorSplash.

FX Photo Studio

One of the highest-rated effects programs is FX Photo Studio, an app that offers 125 effects. It lets you save your tweaked photo at the same resolution you started at—that is, full iPhone 3G or 3GS resolution. You can also crop, rotate, and flip your images.

When you tap to launch Photo Studio, you're prompted with the following options: Take Photo, Load Photo, Options, and Want More?

If you tap Take Photo, you're taken to your camera. After you shoot, you're given a preview. You have two button options here: Retake or Use. If you tap Use, you're taken to the home screen with your picture in it (see Figure 10.26). If you tap Load Photo, you're asked to pick one from your Camera Roll.

Figure 10.26 Home screen of FX Photo Studio.

If you tap Options, you're taken to the screen shown in Figure 10.27.

Figure 10.27 Options for Photo Studio.

The first thing that is listed is a choice of resolutions at which your tweaked photo will be saved. You have a choice of tapping on 320, 640, 800, 1024, 1600, or 2048. The last resolution listed (2048) is the max for the iPhone 3GS.

If you change from Main Menu to Photo Library under where it says "Start App With," you're immediately taken to your Photo Albums when you start Photo Studio. There, you tap on the Camera Roll or album to pick your picture.

If you turn on the Amazing Facts, you get some fascinating trivia while your image is being processed.

After you tap on the photo you want, it appears on the home screen, which has seven icons—four at the top and three at the bottom.

Here is what the top icons do:

■ **Four Horizontal Lines icon.** This icon has only one prompt after you tap it. The app asks you whether you are sure you want to finish editing this image and select another image. If you tap Yes, you're prompted with the same options as if you'd tapped the app icon on your iPhone's home screen.

- **Circle with Arrow icon (Undo).** Tap the Undo icon if you've made an adjustment that you don't like. When you tap it, it will ask you if you are sure you want to undo the current changes. Tap Yes if you are sure, and the image will return to its original state.
- **Filmstrip icon.** This is where all of the effects are. After you tap this icon, a new screen comes up with a listing of categories. Tap a category, and you will get a list of the effects in that category. At the bottom of that screen, there is a button to list all the effects without listing the categories.

The categories and their effects are:

- **Image Correction.** More Contrast, Brighter Image, Vivid Colors, Night Vision, Less Colors.
- **Color Fantasy.** Invert Image, Reduce Colors, Grayscale, Rainbow Palette 1, Rainbow Palette 2, Color Explosion, Color Sunlight Spots, Solarize, Tritone, Tritone 2.
- **Texturize.** Crumpled Paper, Leather Canvas, Texturize, Rusted Metal 1, Rusted Metal 2, Dirty Picture 1, Dirty Picture 2, Rough Fabric.
- **Color Temperature.** Cold Blue, Cool Blue, Cool, Warm, Warm Yellow, Hot Yellow.
- **Overlay.** Water Circles 1, Water Circles 2, Water, Sparkles Big, Sparkles Small, Frost 1, Frost 2, Water Drops 1, Water Drops 2, Fire 1, Fire 2, Teddy Bear, Scary Face 1, Scary Face2, Scary Scull, Ghost, Lightning 1, Lightning 2, Bubbles, Kisses 1, Kisses 2, Steamy Window 1, Steamy Window 2, Color Stars, Hearts.
- **Symmetry.** Symmetry Vertical, Symmetry Horizontal, Symmetry Quad.
- **Glow.** Glow Vivid Color, Glow Grayscale, Glowing Edges.
- **Hue.** Hue Blue, Hue Green, Hue Pink, Hue Turquoise, Hue Purple, Hue Yellow, Hue Red.
- **Vintage.** Old Photo, Burnt Paper, Old Film Frame, Vintage, Vintage Red, Vintage Green, Vintage Blue, Vintage Grayscale, Ancient Canvas, Old TV, Sepia, Vignette 1, Vignette 2, Vignette 3, Vignette 4, Vignette White 1, Vignette White 2, Vignette White 3, Vignette White 4.
- **Art.** Pencil Paint, Neon Light, Mosaic, Noise, Burnt Colors, Black and White, Dark Contours on White, Color Contours on Black, Dark Engraving, Bumpmapping1, Bumpmapping 2, Brush Strokes Dark, Brush Strokes Light, Color Reprint, Overburn Reprint, Abstract Contours, Linocut 1, Linocut 2.
- **Frames.** Butterflies Frame 1, Butterflies Frame 2, Flowers Frame 1, Flowers Frame 2, Cupids 1, Cupids 2, Stardust Frame.

- **Blur.** Radical Blur, Blurred Image, Explosion.
- **Distortion.** False Mirror 1, False Mirror 2, False Mirror 3, False Mirror 4, Rippled Glass 1, Rippled Glass 2, Rippled Glass Dotted.
- **Photo Styles.** B&W Magazine, Amsterdam, Hippie.

After you've applied the effect, it comes up on the screen. Note that you're not finished yet. You have to save it.

- **Disk icon (Save).** The disk icon is for saving the file when it's finished being processed. If you don't save it, it will be lost forever. Figure 10.28 shows what comes on the screen after you tap the Save icon. Tap on the first button, Saved Photos Album, and your photo will be saved in your Camera Roll. Tap Upload, and you have three choices—uploading to Facebook, uploading to Twitter, or emailing the message. Tap Copy to Clipboard, and your image will be copied to the Clipboard.

Figure 10.28 The pop-up screen that appears when you tap the Save icon.

At the bottom of the screen are three more icons: the Scissors option, which lets you crop your image, the Rotate option (two arrows icon), which lets you rotate your image, and the Sun icon, which lets you tweak the gamma (lightness) of your image with a slider.

Although some of the tweaks offered in this app are nothing to write home about (the Pencil tweak almost always comes out too light), there are quite a few that really give amazing results—so good, in fact, that they could be art-gallery worthy. What's so impressive about this

program is how sharp the photos come out when they are finished processing, which is due to the fact that the resulting photo is the same high (relatively) resolution that you began with. Figures 10.29 through 10.37 show some samples of a few of the effects.

Figure 10.29 shows the tweak Art > Linocut 2, one that is similar to the Pencil effect but with much thicker and more detailed lines.

Figure 10.29 Image before and after applying Linocut 2 filter.

The Art > Overburn Reprint tweak really blows highlights and blackens shadows—so much that the photograph turns into something that resembles watercolor. Figure 10.30 shows the dramatic changes that occur with a photo when using this effect. The effect works really well on architecture photos.

The Art > Dark Contours on White effect can take an ordinary photograph and turn it into an abstract painting. The image of the radishes in Figure 10.31 has blown highlights in the red of the radishes. It needn't be tweaked to get rid of them (lowering the saturation would do this); it can just be brought straight into Photo Studio to be tweaked using Dark Contours on White to get a really compelling effect, as Figure 10.31 shows.

Figure 10.30 Image before and after Overburn Reprint tweak.

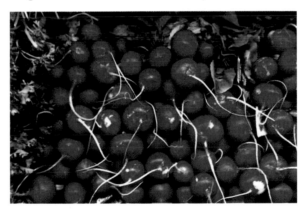

Figure 10.31 Using the Dark Contours on White effect gives an image the feel of an abstract painting.

The Symmetry options are limitless. You have a choice of vertical, horizontal, or quad.

The Symmetry Vertical option takes the left half of the frame and makes it symmetrical with the right, as shown in Figure 10.32.

Figure 10.32 Photo tweaked with Symmetry > Vertical.

Try Symmetry > Symmetry Quad, and you'll get astonishing results if the left quarter of the frame is exposed well and contains compelling elements. This option takes the left quarter of the frame and makes it horizontally and vertically symmetrical. Figure 10.33 shows an image where the left quarter of the frame contains well-exposed, interesting elements. After the quad tweak, you get a design of impeccable quality.

Figure 10.33 The left quarter of the frame is made symmetrical in both horizontal and vertical directions, creating a compelling image after the tweak.

Figure 10.34 illustrates what happens when you make a tweak of an image that is already symmetrical (such as the face of the mannequin). You only get the horizontal component of symmetry because the vertical component of the first quarter is already symmetrical.

Figure 10.34 Mannequin tweaked with the Symmetry > Symmetry Quad.

Color Fantasy > Color Explosion sprays multiple colors that extend outward from the center of the image. It's a great effect for night architecture photos because the color can appear to be coming from a light fixture on the building you take a picture of, as shown in Figure 10.35.

Figure 10.35 Color Explosion can make a building appear to be lit with colored lights.

When you use the Vintage > Vintage Red effect, you can take a photo with flat colors and redden it so that it looks like an antique. This type of effect works really well if you're photographing vintage appliances. Figure 10.36 shows the before and after results with this effect.

Figure 10.36 Old radio tweaked with Vintage Red effect.

One of the better effects is Image Correction > Night Vision. Figure 10.37 illustrates how this effect can lighten dark shadows, revealing what they are covering up.

Figure 10.37 The Night Vision effect will lighten dark shadows, revealing what's underneath.

Photo fx

Photo fx is a powerful lens filter app. There are dozens of lens filters that simulate the effect of having a lens filter on your camera. The app does incredible pencil renderings (Fun fx > Pencil). Figure 10.38 shows one of those renderings with applications of two color filters.

Figure 10.38 Photo fx's Pencil filter does better at pencil renderings than other apps do.

The layout of the program is a bit of a challenge because there are so many filters you can use, and they're located on many different screens under many different categories.

As with most such apps, the initial screen of the program offers four task options, each with an icon on the screen. The first is the Folder icon, which takes you to your Camera Roll to choose an image. The second is the Camera icon, which takes you to the camera to take a picture. You can take a picture after you tap it. You'll then get a preview where there are two options: one to Retake and one to Use. If you like the picture you took, you tap Use. After you either tap Use or select an image from your Camera Roll, the image will appear with all of the different lens options.

The Wrench icon is for adjusting the settings. There are only two options. The first is Save Original Photo, which you can opt to turn on or off with a button to the right of the text. If it's on, the original photo you shot and manipulated is saved along with the final photo you tweaked. In other words, the before and after photos are saved. The next option is Maximum Output Size. If you choose Full, Photo fx lets you save your photo at the same resolution at which you started your tweaking. The other resolutions are 640, 800, 1024, 1280, and 1600.

Finally, there is the Help (question mark) icon, which is what you tap when you need help. The Help section gives some brief information about using the app.

To use the app, all you do is choose a filter category from those listed at the bottom of the screen. For each category there are several variations. For each variation there are several different gradations/strengths/colors of the filter. Once you get down to the different gradations, you tap one in order to see your entire image come into the frame.

If you start out with a picture like the one in Figure 10.39, you can see how the app works.

If you choose Fun fx from the bottom of the screen, your image will come up with seven variations.

If you choose B/W Looks, you have the gradations/strengths/colors shown in Figure 10.40. A thumbnail is displayed for each. When you see dots at the bottom of the variations or gradations/strengths/colors screen (see Figure 10.40), swipe your finger to the right over the screen to go to the next one or to the left to go back. (The number of dots at the bottom of the screen denotes the number of pages.)

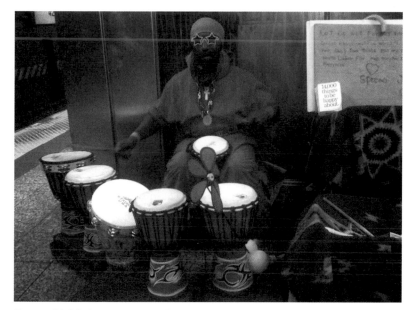

Figure 10.39 Image chosen for running through Photo fx.

Figure 10.40 After choosing a variation, you are taken to a screen with all the different gradations/strengths/colors.

Finally, when your image is shown, you have a row of options at the bottom of the screen (see Figure 10.41). The circle with the line through it is the button to go back. Tapping it will take you back to the thumbnail screen. The icon with two arrows will undo the action after you've applied it. The icon with two sliders will make the sliders appear, which you can use to further tweak the image. The icon with a circle with a dashed line around it lets you set the area in the frame where the effect will be applied. (More about that in a moment, in the listing of filters.) The Crop icon lets you crop your photo, and the Disk icon lets you save your photo.

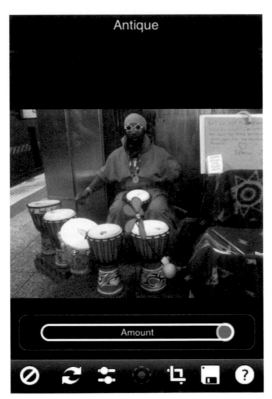

Figure 10.41 The image includes a number of options at the bottom of the screen.

The Disk icon also has an Add Layer option. If you choose it, your current tweak will take effect, and then you'll be taken back to the variations, where you can tap on a new category and/or variation to add another filter on top of the existing one. You can add one filter (layer) on top of another. When you're finished, just tap the Disk icon and then Save.

If you choose the Antique gradation/strength/color, the image shown in Figure 10.41 appears. You have the option to change the amount (using the Amount slider) of the effect if you wish.

If you drop the amount, as shown in Figure 10.42, you get a really cool effect because some of the color reappears in the image, giving it a kind of faded-from-age look.

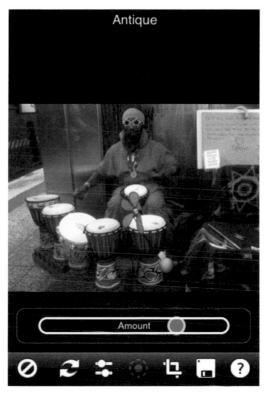

Figure 10.42 Swipe the slider to the left, and the color begins to return.

You then tap the Disk icon (Save command) on the bottom of the screen to save your image.

Figure 10.43 shows the resulting image from the tweak. It's essentially a sepia image with some of the color still showing up—an image that looks as if it has faded over time.

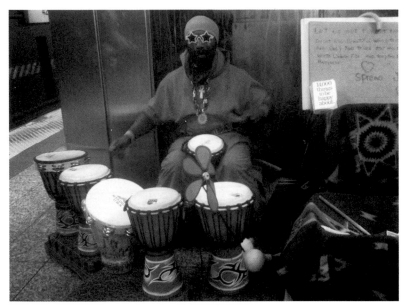

Figure 10.43 Image after adjusting the strength of the Antique effect.

WHAT'S ALL THIS STUFF ABOUT FILTERS?

The filter company, Tiffen, came out with the powerful iPhone app, Photo fx. The program emulates the kinds of filters that you put on your camera to change the light coming through the lens. Tiffen makes filters for movie cameras as well, which is why you see some of the wonderful cinematography in films. There are all kinds of filters, from those that diffuse light to those that bring out different shades of gray in black-and-white photography. The goal when using a filter is to change the color and/or softness of the image without degrading it.

Each of the Tiffen filters—both in the app and for the camera—has a purpose. For example, if you want to change a mediocre sky into a deep-blue sky, you use a polarizing filter. If you want to have more blue tones in your sky (going from darker to lighter from the top to the bottom of the frame), you use an ND (neutral density) filter. If you want a mist effect, say, around plants, you can use the Pro-Mist filter. If you want to soften wrinkles in a portrait, you use a diffusion filter or a soft-focus filter.

Filters come in different grades or strengths, from giving a very subtle effect to entirely changing the way the image looks. Before you use a filter, get an idea of what you want to do with your image and then look at the following list and decide which one(s) you will use. Then, navigate to it in the app.

You can use the following guide to make decisions about what filters you want to use by locating them here and then navigating to them via your iPhone screen.

Face fx

- Black Pro-Mist: Black Pro-Mist 1–9
- Center Spot: Center Spot 1–9
- Pro-Mist: Pro-Mist 1–9
- Soft/FX: Soft/FX 1–9

Outer fx

- Color-Grad (color tints brushed at top of frame): Cranberry, Tangerine, Straw, Tobacco, Chocolate, Plum, Grape, Tropic Blue, Coral, Magenta, Pink, Red, Yellow, Green, Cyan, Cool Blue, Blue
- Day for Night: Day for Night 1–6
- Enhancer: Enhancer 1–9
- Fog: Fog 1–9
- Polarizer: Polarizer 1–9
- Ultra Contrast: Ultra Contrast 1–9

Fun fx

- B/W Looks: 8mm, Aged, Antique, Brownie, Classic, Concord, Cool, Diffuse, Dramatic, Fashion, Flashback, Glamour, Grainy, Grape, Green, Hicon1–3, Hicon Blue, Hicon Copper, Hicon Cyan, Hicon Purple, Hicon Red, High Key, Hollywood, Ice, Moonlight, Newspaper Old, Newspaper, Normal, Pink, Reminiscing, Satin Blue, Scary, Sepia, Steel, Still Life 1–2, Warm
- Color Looks: 8mm, Basic, Black Diffusion, Bleach Bypass, Bright Shade, Burnt Copper, Color Reversal, Cool Desaturated, Cross Process, Dreamy, Faded, Faux Film, Glamour, Photocopy, Punchy, Push Process, Radiant, Romantic, Sixties Slide, Soft Diffusion, Sunset, Transparency, Warm Desaturation, Warm Diffusion, White Diffusion
- Color Spot: Cranberry, Tangerine, Straw, Tobacco, Chocolate, Plum, Grape, Tropic Blue, Coral, Magenta, Pink, Red, Yellow, Green, Cyan, Cool Blue, Blue
- Infrared: Normal Filter, Red Filter, Green Filter, Blue Filter, Yellow Filter, Orange Filter
- Pencil: Pencil 1–5 (lightest to darkest)
- Reflector: Gold, Silver
- Star: Star 1–9

Wild fx

- Glow: Glow 1–9
- Grain: Basic, Basic Monochrome, Big, Big Monochrome, Heavy, Heavy Monochrome, 25ASA, 5245 50ASA, 100ASA, 5247 100ASA, 5248 100ASA, 5274 200ASA, 5287 200ASA, 5293 200ASA, SFX 200, 5246 250 ASA, 5277 320ASA, 5294 400ASA, 400ASA, 5279 500ASA, 5284 500ASA, 5289 800ASA, 5296 500ASA, 5298 500ASA, 800ASA, 1600ASA

- Halo: Halo 1–5
- High Contrast: High Contrast 1–5
- Night Vision: Blue 1–5, Green 1–6, Orange 1–6, Red 1–6
- Three Strip: Three Strip 1–6
- Two Strip: Two Strip 1–6

Classic fx

- Black and White: Normal, Red, Green, Blue, Yellow, Orange
- Old Photo: Cyanotype, Kalitype, Light Cyan, Palladium, Sepia, Silver, Silver Gelatin, Van Dyck
- Temperature: Warm 10%–90%, Cool 10%–90%
- Tint: Blue, Cyan, Green, Magenta, Orange, Red, Violet, Yellow
- Vignette: Black Circle, Black Square, White Circle, White Square

Lens fx

- Close-Up Lens
- Depth of Field (see Figure 10.44)
- Wide Angle Lens

Figure 10.44 The black in the squares in the row of icons at the bottom of the screen indicates where in the frame your image will be sharp.

Portrait fx

- Black Diffusion/FX: Black Diff/FX 1–9
- Bronze Glimmer: Bronze Glimmer 1–9
- Cool Pro-Mist: Cool Pro-Mist 1–9
- Diffusion: Bark 1–3, Broom, Bubbly 1–2, Ceramic Pot, Ceramic Tiles, Clouds, Concrete 1–2, Cracked Wood, Dirty Metal, Donkey Fur, Fatigued Metal, Fragmented, Gauze, Glass, Glass Brick, Glass Square, Glass Window, Granite, Leather, Lichen, Marble, Material Pattern, Mosaic, Moss, Paint Splodge, Painted Metal 1–2, Pattern 1–3, Pebbles 1–3, Plastic, Reflective, Rust 1–2, Saucepan, Shells, Slate, Speckled, Strata, Streaked Metal, Termite Colony, Wet Slate, Worm Metal
- Faux Film: Faux Film 1–9
- Glimmerglass: Glimmerglass 1–9
- Gold Diffusion/FX: Gold Diff/FX 1–9
- HDTV/FX: HDTV/FX 1–9
- Smoque: Smoque 1–9
- Soft Light: Soft Light 1–9
- Streaks: Horizontal 1–3, Vertical 1–3
- Warm Black Pro-Mist: Warm Black 1–9
- Warm Center Spot: Warm Spot 1–9
- Warm Pro-Mist: Warm Pro-Mist 1–9
- Warm Soft/FX: Warm Soft/FX 1–9

Color fx

- 812 Warming: 812 Warming 1–9
- Bleach Bypass: Bleach Bypass 1–3, Warm 1–3, Cool 1–3
- Color Infrared: Color Infrared 1–5
- Cross Processing: Print to Slide 1–3, Slide to Print 1–3
- Dual Grad: Blue-Magenta, Blue-Orange, Blue-Red, Magenta-Blue, Magenta-Orange, Magenta-Red, Orange-Blue, Orange-Red, Red-Blue, Red-Magenta, Red-Orange
- Fluorescent: Fluorescent 1–9
- Haze: Haze 1–9
- Mono Tint: Blue, Cyan, Green, Magenta, Orange, Red, Violet, Yellow
- ND-Grad: ND.3, ND.6, ND.9, ND1.2
- Nude/FX: Nude/FX 1–6.
- Sky: Sky 1–9.
- Strip Grad: Cranberry, Tangerine, Straw, Tobacco, Chocolate, Plum, Grape, Tropic Blue, Coral, Magenta, Pink, Red, Yellow, Green, Cyan, Cool Blue, Blue.
- Sunset/Twilight: Sunset 1–3, Twilight 1–3.
- X-Ray: X-Ray 1–6.

Light fx

- Ambient Light: Ambient Light 1–7, Ambient Light 9–10
- Edge Glow: Edge Glow 1–9
- Ice Halos: 0 Degrees, 5 Degrees, 10 Degrees, 15 Degrees, 20 Degrees, 25 Degrees, 30 Degrees, 35 Degrees, 40 Degrees…90 Degrees
- Light (Breakups) (see Figure 10.45 for patterns): Radial Lines, Snowflakes, Flame, Shatter, Linear, Homespun, Twister, Linear City, Graduated, Sparkler, Paisley, Grille, Diagonal, Bricks, Scattered Lines, Broken Lines, Small, Potpourri

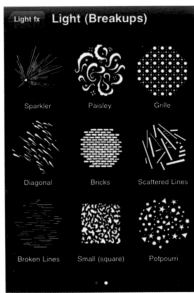

Figure 10.45 Patterns for Light Breakups.

- Light (Foliage) (the same idea as Light Breakups): Jungle Leaf, Palm Leaves, Leaf Breakup, Tropical (palm fronds), Breakup 1–3, Sharp, Bamboo Leaves, Dense Foliage, Reversed Trees, Evergreens (a row of them), Saplings, Winter Trees, Evergreens 2, Twisted Tree, Japanese Bamboo, Thin Bamboo, Giant Grass, Christmas Tree, Open Leaves, Sharp (Square), Mountain Shrub, Summer Branches, Giant Trees, Grove, Open
- Light (Lights): Spotlight 1–7, Heart, Searchlights, Beams, Row of Lights, Circle of Lights, Wavy Searching, Krelve, Pools of Light, Light Ray 1–3
- Light (Windows): Spanish Shutters, Old Blinds, Office 2, Office 1, Elizabethan, Bars, Window Shades, Venetian Blinds, Shutters, Double Hung, Tracery, Bay, Chancery, Georgian, Tenement, Chinese Doors, Tudor 2, Byzantine, Austrian Curtain, Grid, Curtains, Café Curtains, Lace Medallion, Plaid 1–2, Office 3, Crooked Blinds, French Doors, Church Window, Entry
- Relight
- Water Droplets: Corona, Fogbow, Glory.

There's one more option to illustrate. Sometimes the dashed circle icon is activated (it shows up lit on the screen). If this is the case, it means that you can move and stretch the tweak around. Let's see how this works.

After choosing an image of a wine glass with a city background (see Figure 10.46), I navigated to Light fx > Relight and got to the screen that looks like the one shown in Figure 10.47. I found that the image lit up some in the center. I left the Brightness, Blur, and Displacement sliders alone, noting that when I fooled with the circle of light, it became not so subtle. (It changes into a bright circle of light with markedly different brightness where the circle ends.) Blurring with the slider, it makes a haze, and the Displacement slider doesn't change anything. I then tapped the dashed circle at the bottom of the screen. The position of the circle of light is shown on the screen as you see in Figure 10.48.

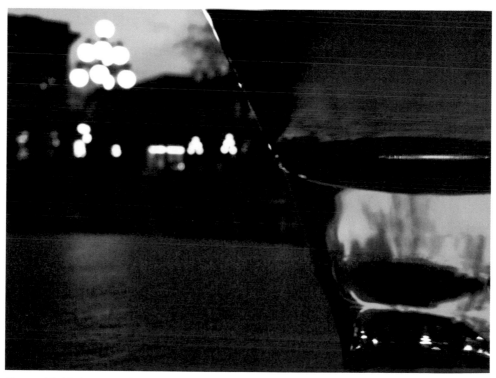

Figure 10.46 Image before tweaking with the Relight option.

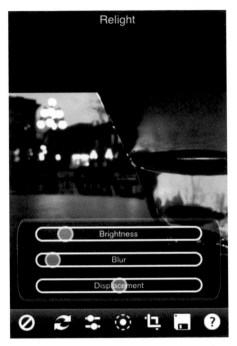

Figure 10.47 Screen that comes up after tapping the Relight option.

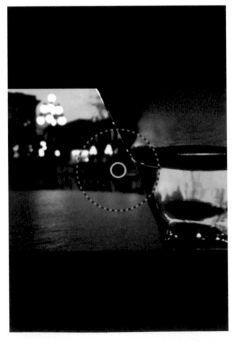

Figure 10.48 When you tap the dashed circle at the bottom of the screen, a circle of light guide appears for you to move around.

NOTE

You can change the diameter of the circle of light by swiping the dashed circle inward or outward. You can move the circle of light by swiping the center of the circle of light to a place where you want it on the screen.

Now, I can move the circle of light. What really makes the image change to an effect I like is moving the circle of light into the water. Figure 10.49 shows where I moved the circle to.

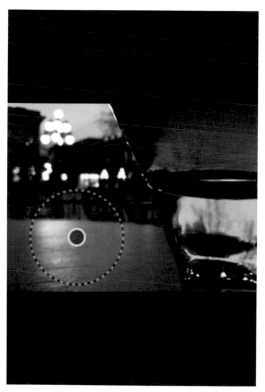

Figure 10.49 You can move the circle of light.

Figure 10.50 shows the image after applying the Relight filter and moving around the circle of light.

Figure 10.50 Final image after applying the Relight filter.

Tweaking with Two Filters

In another example of using two filters using the Add Layer option, you can come up with a rather ephemeral image. Here's what you can do:

Begin with a portrait—any portrait that's fairly close-up, such as the one shown in Figure 10.51.

Now navigate to Fun fx > Color Spot > Tobacco. (You could also opt for other colors.) On the screen (see Figure 10.52) you have three options when processing the Tobacco color: Color, Softness, and Amount. I opted to increase the Softness (the second slider in Figure 10.52—you can't see the word, but it's there) so that the color spreads to more of the background instead of being concentrated at the edges. I left the Color the same, but if you look at the figure, you can see that when you tap Color, a color wheel comes up where you can change the color by tapping the wheel or the rectangle inside.

Figure 10.51 The white background in this image can be made to look better if you add some color.

Figure 10.52 You can adjust three options when tweaking an image in Fun fx > Color Spot.

Next, I see that the image needs some softening, so I opt to add a layer by tapping the Disk icon and then tapping Add Layer. I navigate to Face fx > Soft/FX > Soft/FX 3. The screen in Figure 10.53 comes up. At this point I don't touch the sliders; I like the effect as is.

Figure 10.53 You can make your image softer by applying Face fx > Soft/FX > Soft/FX 3.

Finally, I tap the Disk icon and tap Save, which gives me the image shown in Figure 10.54.

There's another good way to use two filters. Sometimes the iPhone won't give you a sky that is deep blue with blue tonal variations—instead, you get something like the photo you see in Figure 10.55. You can employ two filters to get a better sky:

1. Color fx > ND-Grad > ND 1.2. (ND is the Neutral Density filter, which adds gradations to the sky.)
2. Outer fx > Polarizer > Polarizer 8. (The Polarizer filter deepens the blue tones.)

Figure 10.55 shows the before-and-after images of these tweaks.

Figure 10.54 Final image after tweaking with two filters.

Figure 10.55 Buildings before and after tweaking the sky.

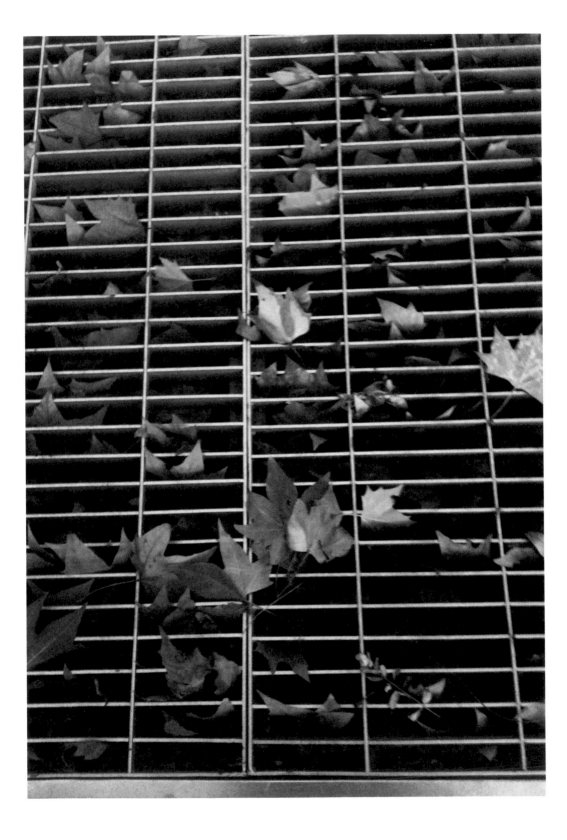

Sharing Your Killer Photos

A t this point in the book, you should have a pretty good idea of how to create killer iPhone photos. And so at this point, you'll probably want to share them with the world…and you can.

Sharing via Apps

There are many apps that let you share your photos to a number of sites, such as Flickr, Facebook, Twitter, Blogger, and WordPress blogs. These apps are AroundShare, PixUp, Twitxr, and Best Camera.

You can also send your photos to photo-sharing sites via Photogene (discussed in Chapter 8). To do that, you tap the check icon at the bottom of the column of icons when you are finished tweaking your image. Then tap Share on the screen that comes up. Figure 11.1 shows you that you have a choice to share your photo on Twitter or Facebook.

Figure 11.1 You can upload your photos to Facebook or Twitter using Photogene.

Another app that lets you share your photos is PhotoStudio. All you have to do is tap the Disk icon (in the top row of icons) when you're finished tweaking your image. A pop-up screen will appear, where you can tap on Upload. You then will see two giant buttons that read Facebook and Twitter. Tap either to share on one of those sites.

Finally, ColorSplash also lets you share your photos. After you're finished tweaking an image, you tap the Menu icon in the top row of icons. On the next screen, you tap Share/Send image. You'll have a choice to upload to either Facebook, Flickr, or Twitter on the next screen.

For the purposes of this book, I will discuss uploading back and forth from your iPhone to your computer for Flickr and Photobucket.

Sharing on Flickr

Because Flickr is a good outlet to display your photos, I'll start there. The first thing you have to do is get the Flickr app from the App Store. To do that, you just tap the App Store icon on your iPhone's home page.

Once you've tapped the Flickr icon on the home screen of your iPhone, you'll be taken to the screen shown in Figure 11.2. On that screen, you tap the camera in the upper-right side. If you haven't used the app yet, you'll get a message saying, "We will now launch Safari so you can log in and authorize this application." Tap OK. Sign in on the next screen. The next thing you do is authorize your account.

Figure 11.2 Screen that comes up after tapping the Flickr app icon on the home screen of your iPhone.

If you have used the app and are already logged on, you'll get the screen shown in Figure 10.2 after you've tapped on the Flickr icon on your iPhone home screen. When you tap the camera icon in the right corner of the screen, you'll be prompted to Take Photo or Video or Upload from Library. To get an image from your Camera Roll, tap Upload from Library and navigate to the image you want.

A screen will come up with fields for Title, Description, Sets, Tags, Image Size, and other options for the image (see Figure 11.3). After you fill in those fields (you don't have to—they are optional), you tap Upload. Flickr will then upload your image to your Photostream.

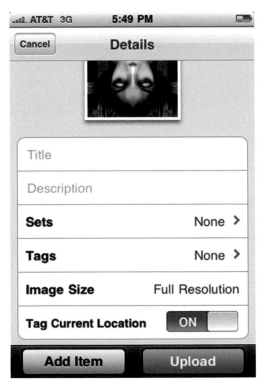

Figure 11.3 You can opt to lower the resolution when uploading a photo from your iPhone to Flickr by tapping Full Resolution, which will change to Medium Resolution after you tap it.

Here's a review of what the icons do on the Flickr home screen.

- **i.** The i icon in the upper-left corner of the screen gives you general Flickr info.
- **Camera.** The camera icon in the upper-right corner is where you either take a photo or upload one from the library to put on Flickr.
- **Recent.** This shows you the most recent activity and uploads.

- **You.** Tap this, and you get to your Photostream.
- **Contacts.** This is a list of your contacts.

The two most important features of Flickr regarding your iPhone are that you can upload photos from your iPhone to Flickr with your iPhone (in high resolution), as explained a moment ago, and that you can save photos from Flickr to your iPhone (not at high-res yet).

> **NOTE**
>
> If you want to get a high-res photo from Flickr to your iPhone, email it to yourself from your computer and then access that email on your iPhone and download it.

To download photos from Flickr to your iPhone, tap You on the home screen. Tap one of your photos on the next screen. It comes up by itself on the next screen (see Figure 11.4). On that screen tap the arrow inside the rectangle icon. On the pop-up screen that comes up, tap Save Image.

Figure 11.4 You can download an image from Flickr to your iPhone by tapping the icon in the lower-left part of the screen.

Sharing Using Photobucket

If you don't have Photobucket preinstalled on your iPhone, you can get it for free from the App Store. After you tap the Photobucket icon, you're taken to the home screen shown in Figure 11.5. (If you haven't registered, it will ask you to do so.) On the bottom of the screen are the following options:

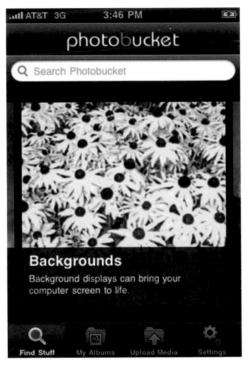

Figure 11.5 Photobucket home screen.

- **Find Stuff.** Tap this, and a Search box comes up, which you can use to search for different kinds of photos.
- **My Albums.** After you tap this icon, you'll be shown the images you have in Photobucket. Tap one of the images, and it is shown full-screen.
- **Upload Media.** This is the place where you can choose an existing photo from your Camera Roll or choose Use Camera to take a shot to upload to Photobucket.
- **Settings.** In the Settings menu, you can turn on and off several features (see Figure 11.6), including Ads, General (Start screen options and an option to view optimized photos), Download (an option to download full-res photos), Upload (default album, title, and description and an option to compress uploads).

Just as with Flickr, the two most important features of Photobucket regarding your iPhone are that you can upload photos from your iPhone to Photobucket (in high resolution) and that you can save photos from Photobucket to your iPhone (not at high resolution yet, but at better resolution than in Flickr).

Figure 11.6 You can opt to lower the resolution when downloading a photo from your iPhone to Photobucket by turning off the Download Full-Res Photos option in the Settings.

To upload your photo from your iPhone to Photobucket, tap the Upload Media icon. Tap Choose Existing if you want a photo from your Camera Roll or Use Camera if you want to upload an image you are about to take. Navigate to the photo you want to upload and then click. The upload will proceed automatically.

To download an image from Photobucket to your iPhone, tap My Albums and then tap a photo. It will come up full-screen. Just as in Flickr, tap the arrow inside the rectangle icon and then tap Download when the pop-up menu appears. The photo will automatically download into the Camera Roll.

Index

A

actions, freezing, 76
albums and thumbnails, 34
all-white background, 65–66
angles, 77–79
animals, interacting, 76
aperture, 10, 12–13
Aperture Priority mode, 13, 37
apps
 AroundShare, 246
 art and images, 12
 Best Camera, 246
 Brushes, 165, 169–180
 buying, 25–27, 130
 CameraBag, 180–193
 Camera Genius, 137–141
 ColorSplash, 70, 212–217
 credit cards and, 28
 description, 27, 28
 downloading, 27
 Epson iPrint, 157
 finding, 26, 28
 Flickr, 247–249
 free, 25
 FX Photo Studio, 218–226
 Ghost Capture, 106
 Imikimi, 161–163
 iPrintApp, 157
 iPrintMe, 157
 iPrint Photo, 157
 listing, 5, 26

 Night Camera, 126
 NoiseBlaster, 74, 122
 photo-editing, 166–168
 PhotoForge, 154, 196–212
 Photo fx, 227–243
 Photogene, 144–149, 158–159
 photographing with, 132–141
 Photoshop Mobile, 54, 88, 98, 154, 160, 166–168
 PixUp, 246
 Print, 157
 printing photos, 157
 ProCamera, 133–136
 ProCamera Basic, 133–136
 Resizer, 17, 145
 Scissors, 150–153
 searching for, 131–132
 sharing photos, 246–251
 Simple Resize, 144
 TiltShift, 112
 Twitxr, 246
 updating, 130–131
App Store, 26–28
 buying apps, 130
 photography section, 131–141
 searching, 131–132
App Store icon, 130–132
architecture
 buildings and bright colors, 54
 contrast between building and sky, 91
 converging lines in, 92–94

elements, 97

 framing elements, 97

 graffiti, 96

 keeping sun behind, 90

 negative space, 94

 photographing, 90–97

 shooting from distance, 93

 tilting camera upward, 92

 varying shots, 91

AroundShare, 246

art

 found art, 108–109

 photography as, 107–109

 still lifes, 107

aspect ratio, 155–156

Auto Enhance, 202

Auto Exposure, 202

auto-focus 3-MP cameras, 5

autofocus point, 36

automatically taking three pictures, 140

automatic ISO speed, 40

Auto White Balance, 202

B

backgrounds, 35

 all-white, 65–66

 compelling and flowers, 87

 distracting, 43

 interesting, 71

 neutral colors, 65, 66

 portraits, 65–66

 shooting at angle, 79

 sporting theme, 71

 vast landscapes, 71

barrel of distortion, 62

Best Camera, 246

Bicubic Sharper, 24

black and white photos, 168, 190

 painting back color on, 217

bleached-out Polaroid colors, 187

Blur, 202

blurring

 images, 112, 168, 202

 moving objects, 80

body parts, 59

 faces, 82

 iPhone 3G and iPhone 3GS, 80

 isolating shoes, 81

 legs and feet, 81

 photographing, 80–83

borders

 customizing, 158–159

 photos, 157–163

Bridge, 13

bright colors

 buildings, 54

 frames, 50–55

Brushes, 165

 Add to Photos command, 171

 Brush panel, 177

 Camera Roll, 171

 color on transparent layer, 175

 Color Picker, 172, 179

 deleting photos, 171

 Duplicate Painting command, 171, 172

 duplicating photos before changing, 172

 Email Painting command, 171

 eraser, 177

 Eyedropper tool, 172

 Gallery of Images, 170–172

 Layers panel, 172, 174–177

 New Yorker (June 2009), 169

 paintbrushes, 177

 Paintbrush panel, 172

 Painting mode, 172–179

 quickly changing tools, 180

 saving images, 177

 selecting layer, 175

 undoing and redoing actions, 172, 173

 Viewing mode, 170–172

 zooming pictures, 173

brushes, 177, 216
 color, 178, 201
 Eyedropper, 178
 hue and saturation, 179
 paint transparency, 201
 resizing, 200
 types, 200
buildings and bright colors, 54
buying apps, 25–27

C

calculating exposure, 38
CameraBag
 camera icon, 180
 Cinema filter, 191
 Colorcross filter, 189
 disk icon, 180
 envelope icon, 180
 filters, 180–193
 Helga filter, 182
 Infrared filters, 184
 Instant effect, 187
 listing filters, 181
 Lolo filter, 185
 Magazine filter, 186
 Mono filter, 190
 1962 filter, 192
 1974 filter, 182, 188
 saving image, 182
 Silver filter, 193
Camera button, 33
Camera Genius, 138–140
Camera icon, 5, 33
Camera Roll, 34
 choosing image, 228
 deleting images, 35
 exporting photo to, 177
 importing photo from, 180, 218
 saving images to, 171, 180

 selecting image, 212
 thumbnails, 34
cameras
 anti-shake sensor, 138
 aperture priority mode, 37
 aspect ratio, 155–156
 auto-focus 3-MP, 5
 automatically orienting framing to landscape, 33
 Automatic mode, 38
 deleting photos after downloading, 18
 dSLR, 11
 fixed-focus 2-MP, 5
 handiness, 12
 holding, 33, 40
 lens, 6, 32, 37
 light, 40
 moving around to focus, 40
 parts, 5–6
 refocusing, 86
 retaking pictures, 218, 228
 sensitivity, 135
 sensor, 10
 set aperture, 13
 set focal length, 155
 settings, 10–16
 shutter speed, 13
 specs, 10–16
 taking pictures, 200, 218, 228
 tapping anywhere onscreen, 138
 tilting upward, 59, 92
 timer, 135
 touch-screen focus, 5
 zoom lens, 42–43
camera shake, 40
Cancel button, 35
Canon digital camera, 11
Categories icon, 132
CIE Lab color space, 203
Cinema filter, 191
Classic fx filters, 234

close-ups, 62
>lighting, 50
>objects, 48–50
>sharpness, 39

cloudy days, 119

CMYK color space, 203

color
>increasing saturation, 98
>splashing surroundings with, 69–70

Colorcross filter, 189

Color fx filters, 235

Color mode, 217

colors, 228
>adding to images, 215
>bleached-out Polaroid, 187
>brightness, 179
>brushes, 178, 201
>changing amount, 230–231
>changing to gray, 214
>complementary, 53
>fading, 182
>frames, 198
>lighting, 50–55
>more basic form of, 206
>opacity, 179
>Paint Can (Fill tool), 201
>painting back into photo, 70
>painting on black and white photos, 217
>picking upon onscreen, 198
>reflections drastically changing, 117
>selecting, 201
>still lifes, 52–53
>sunset or sunrise, 106
>taking away, 217
>tonal range, 206
>tool shed, 50–51
>transparency, 179
>transparent layer, 175
>tweaking by, 203

ColorSplash, 70
>Brush icon, 216
>Color icon, 217
>Color View mode icon, 215
>converting photo to black and white, 212
>Copy to Clipboard option, 214
>Gray icon, 217
>Help icon (question mark), 215
>help videos, 215
>Invert Color to Gray option, 214
>Load Session screen, 213
>Menu icon (horizontal lines), 213–214
>Pan & Zoom icon, 217
>Post to Twitter option, 214
>Red View mode icon, 215
>retaking image, 212
>saved sessions, 213–214
>saving images, 212–213
>Share/Send Image option, 214
>sharing photos, 247
>taking pictures, 212
>Upload to Facebook option, 214
>Upload to Flickr option, 214

color theory, 52–53

color tones and sunlight, 118

complementary colors, 53

computers, synching iPhone to, 24–25

contacts, listing, 249

contrast
>decreasing, 168
>getting better, 91
>increasing, 168, 185
>providing eye with vivid experience, 94

cool blue tones, 189

credit cards, charging apps to, 28

cropping app, 135

cropping photos, 146–156, 167, 221, 230
>aesthetics, 155–156
>Rule of Thirds, 155

Curves, 203

curving lines, 203

D

Delete Photo button, 35
depth of field, 37
digital photography, changes to, 11–12
digital zooms, 135
direct lighting, 118–122
direct sunlight indoors, 121
distracting background, 43
downloading apps, 27
Download To drop-down menu, 18
dSLR cameras, 11
 aperture priority mode, 37
 aspect ratio, 155

E

editing applications, 12
effects, taking picture with, 180
emailing images, 214
Epson iPrint, 157
erasing painting, 198
Exposure, 202
exposure
 calculating, 38
 increasing or decreasing, 167
Eyedropper, 178
eyes and Rule of Thirds, 57

F

Face fx filters, 233
faces, 82
fading color, 182
files
 saving after processing, 221
 sizes, 8, 10
filters
 CameraBag, 180–193
 Cinema filter, 191
 Classic fx, 234

 Colorcross filter, 189
 Color fx, 235
 Face fx, 233
 Fun fx, 233
 Helga filter, 182
 infrared, 184
 Instant effect, 187
 Lens fx, 234
 Light fx, 236
 listing, 181
 Lolo filter, 185
 Magazine filter, 186
 Mono filter, 190
 1962 filter, 192
 1974 filter, 182, 188
 Outer fx, 233
 PhotoForge, 201–212
 Photo fx, 232–236
 Portrait fx, 235
 purposes, 232
 Silver filter, 193
 Wild fx, 233–234
finding apps, 28
fixed focus, 12, 35
fixed-focus 2-MP camera, 5
flash, lack of, 41
Flickr, 247–249
flipping images, 167
flowers
 focal point, 87
 photographing, 86–89
focal point
 landscapes, 103
 placing, 106
focus, moving camera around for, 40
fog, 104
folders for photos, 18
found art, 108–109
frames
 better contrast, 91
 body parts, 59

bright colors, 50–55

color, 198

converging lines in, 92–94

cool blue tones, 189

eliminating noise, 74

fitting buildings into, 90

left half symmetrical with right half, 224

left quarter horizontally and vertically symmetrical, 224

shadows around periphery of, 65–66

framing

architectural elements, 97

photos, 55–58, 157–163

free apps, 25

freezing action, 76

Fun fx filters, 233

FX Photo Studio

Amazing Facts, 219

Art > Dark Contours on White effect, 222

art effects, 220

Art > Linocut 2 effect, 222

Art > Overburn Reprint effect, 222

blur effects, 221

Circle with Arrow icon (Undo) icon, 220

Color Fantasy > Color Explosion effect, 226

color fantasy effects, 220

color temperature effects, 220

Dark Contours on White effect, 222

Disk icon (Save), 221

distortion effects, 221

Filmstrip icon, 220–221

Four Horizontal Lines icon, 219

frames effects, 220

glow effects, 220

hue effects, 220

image correction effects, 220

Image Correction > Night Vision effect, 226

Load Photo option, 218

Options option, 219

overlay effects, 220

Photo Albums, 219

photo styles effects, 221

resolution, 218, 219

Scissors option, 221

sharp photos, 222

symmetry effects, 220

Symmetry options, 224

Symmetry > Symmetry Quad option, 224

Symmetry Vertical option, 224

Take Photo option, 218

texturize effects, 220

trivia while image is processed, 219

tweaking symmetrical images, 225

undoing changes, 220

vintage effects, 220

Vintage > Vintage Red effect, 226

G

Gallery of Images, 170–172

gamma, 221

Gaussian blur, 112

geometrical shapes, 52, 53

Ghost Capture, 106

ghosts as subjects, 106

GIF files, 23

glowing black-and-white images, 184

gradations, 228

graffiti and architecture, 96

gray, changing to color, 214

groups

lighting, 73

positioning, 72–73

shooting at angle, 77

subjects interacting, 74–75

H

hazy images, 46

HDR (High Dynamic Range), 206

Helga filter, 182

High Dynamic Range. *See* HDR (High Dynamic Range)

highlights, blowing, 222

home screen, 5

 Camera icon, 33

 Photos icon, 34

HP printers, 157

hue

 brushes, 179

 modifying, 207

I

Image Capture, 17

image processing software, 17, 54

Image Resize dialog box, 23–24

Imikimi, 161–163

Import Pictures option, 19, 21

indirect light, 118–122

indoor light, 121–122

infrared filters, 184

Instamatic camera, 187

Instant effect, 187

interacting subjects, 74–75

interesting backgrounds, 71

internal flash drive, 5

Internet

 JPEG, GIF, and PNG files, 23

 resizing images for, 17

inverting images, 99

iPhone

 automatically downsizing to low resolution, 22

 buying apps, 130

 camera parts, 5–6

 downloading and installing apps, 130

 exporting images to Macintosh, 17–18

 exporting photos to Windows, 19–21

 indoor light, 121

 lack of flash, 41

 removing photos, 22

 resizing photos, 144–145

 sharpness, 40

 showing movement, 80

 shutting down, 5

 Sleep mode, 5

 Sleep/Wake button, 4

 synching, 24–25

 transferring images from computer, 21–22

 turning on, 4

 unlocking, 4–5

 vibrating when finished saving photo, 136

iPhone 3G

 aperture, 12

 body parts, 80

 exposure, 91

 file sizes, 10

 fixed focus, 5, 12, 35

 internal flash drive, 5

 light, 40

 number of images, 5

 original sizes of photos, 17

 resolution, 10

 sensor, 10

iPhone 3GS

 aperture, 12

 auto focus, 5, 36

 body parts, 80

 depth of field, 36, 37

 exposing photos using available light, 13, 38

 exposure, 91

 file sizes, 10

 focal length, 10

 focus, 34–36

 internal flash drive, 5

 ISO speed, 13

 macro lens, 39

 original sizes of photos, 17

 photographing flowers in sunlight, 87

 reduced noise, 15

 resolution, 10

 sensor, 10

 sharpness, 15

taking pictures, 34
tap focus, 13, 36, 38–39, 49
tilting and turning to get best exposure, 91
touch-screen focus, 5
up-close photos, 48
iPhoto, 54, 69–70
iPrintApp, 157
iPrintMe, 157
iPrint Photo, 157
ISO speeds, 115
adjusting to light, 41, 123
automatic, 13, 40, 123
high or low, 15
iPhone 3GS, 13
lowest, 41
reduced noise, 15
iTunes
App Store, 26–28
Photos tab, 21
synching iPhone, 24–25
transferring images to iPhone, 21–22

J

JPEG files, 23

K

Ketchum, Greg, 11, 69–70
Krug, Kris, 11

L

landscape mode, 32
fingers blocking lens, 33
wide buildings, 90
landscapes
focal point, 103
ghosts as subjects, 106

lighting, 102
photographing, 100–105
Rule of Thirds, 100
during sunrise or sunset, 105
tap focus, 103
weather, 104
layers, 174–175
layer styles, 24
lens, 6, 32
blur, 112
curvature of, 62
focus, 12–13
iPhones, 37
Lens fx filters, 234
Light fx filters, 236
lighting, 115
camera, 40
close-ups, 50
colors, 50–55
direct and indirect, 118–122
groups, 73
harsh and direct to soft and diffused, 117
indoors, 122
iPhone 3G, 40
ISO speed, 115
landscape, 102
optimal, 48
outdoors, 46
out of direct sunlight, 46
reflective, 116–117
shade, 46–48
sharp photos, 46–48
shutter speed, 115
subjects directly under, 121
tropical lights, 46
lines, curving, 203
Lolo filter, 185
low-resolution photos, 177

M

macro lens, 39, 86

Macs, getting photos from iPhone to, 17–18

Magazine filter, 186

Magnifying Glass, 198

Microsoft Office Document Scanning option, 19

Model, Lisette, 59

Mono filter, 190

motion blur, *80*

movement blur, 59, 125

moving objects, blurring, 80

N

ND (neutral density) filter, 232

negative space and architecture, 94

Neutral Density filter, 242

New Yorker **(June 2009),** 169

New York Times **(2009),** 180–193

Night Camera, 126

night photography

 blown highlights, 123

 ISO speed, 123

 manmade light, 123

 multiple colors extending outward from center, 226

 noise, 123, 202

 resolution, 126

 sharpening, 126

 subjects/objects far away, 123

 trails from cars, 125

1962 filter, 192

1974 filter, 182, 188

noise

 eliminating, 74, 122

 night photography, 123

 reducing, 15

NoiseBlaster, 74

Noise Reduction, 202

nondistracting background and portraits, 62

O

objects

 closing in on, 48–50

 details, 48–49

 zooming, 48, 138

101 Quick and Easy Ideas Taken from the Master Photographers of the Twentieth Century, 59

Open Device to View Files option, 19, 20

optimal lighting, 48

outdoor lighting, 46

Outer fx filters, 233

overexposed sky, 38, 91

overexposing images, 38–39

P

Paintbrush mode, 198

Paint Can (Fill tool), 201

painting

 black and white photos, 217

 brushes, 177

 erasing, 198

 images, 198

 layers, 174

 taking away color, 217

 transparency, 201

panning, 217

part sharp and part soft images, 49

perspective, worm's-eye view, 111

Photo Albums, 34, 219

Photobucket and sharing files, 250–251

photo-editing apps, 166–168

PhotoForge

 adjustments, 201–208

 auto adjustments, 202

 Auto Enhance, 202

 Auto Exposure, 202

 Auto White Balance, 202

 Black and White effect, 210

 BlueSky effect, 212

Blur, 202

Camera option, 200

Clone Stamp, 199

cropping images, 154

Crop tool, 201

Curves, 203

drawing on blank page, 197

Dreamy effect, 209

effects, 201, 209–212

Emboss effect, 212

Eraser, 198

Exposure, 202

Eyedropper, 198

Filters (T icon), 201–212

Finger (Smudge tool), 199

Folder icon, 199–200

Heat Map effect, 210

Hue/Saturation option, 207

Levels option, 204

Lomo effect, 209

Magnifying Glass, 198

Negative effect, 212

Neon effect, 211

New option, 200

Night Vision effect, 210

Noise Reduction, 202

Oil Painting effect, 210

opening photos, 197

Open option, 200

output files at full resolution, 196

Paintbrush, 198, 200

Paint Can (Fill tool), 198

Paint Palette icon, 201

Pencil effect, 210

Posterize effect, 210

Sepia effect, 210

Sharpen, 202

Simulated HDR, 206

Sin City effect, 210

Sunset effect, 212

taking pictures, 197

Television effect, 212

Tilt Shift option, 208

Unsharpen Mask, 205

Vibrance, 202

Vignette effect, 209

Watercolor effect, 210

Photo fx

Add Layer option, 230, 242

adjusting settings, 228

Antique gradation/strength/color, 230–231

area where effect applied, 230

B/W Looks, 228

Camera icon, 228

circle of light, 237–239

Color fx > ND-Grad > ND 1.2 filter, 242

Crop icon, 230

Disk icon (Save command), 230, 231, 242

Face fx > Soft/FX > Soft/FX 3 effect, 242

filters, 228, 230, 232–236

Folder icon, 228

Fun fx, 228

Fun fx > Color Spot > Tobacco filter, 240

Help (question mark) icon, 228

image variations, 228

layers, 242

lens filters, 227

Light fx > Relight filter, 237

Maximum Output Size option, 228

moving and stretching tweak, 237

Original Photo option, 228

Outer fx > Polarizer > Polarizer 8 filter, 242

Pencil filter, 227

pencil renderings, 227

resolution, 228

Retake option, 228

Save Original Photo option, 228

sliders, 230

thumbnail screen, 230

tweaking with two filters, 240–243

undoing action, 230

Use option, 228

variations, 230
Wrench icon, 228

Photogene
black vignetting, 159
borders, 158–159
cropping photos, 146–149
reflections, 159
resizing photos, 144–145
rotating photos, 148
Scissors icon, 146
sharing photos, 246
straightening out photos, 148

photographing
architecture, 90–97
body parts, 80–83
landscapes, 100–105
people without permission, 42
person without showing head, 82

photography
as art, 107–109
night, 123–125
rules made to be broken, 57
still-life, 107
street, 109–112

photography apps, listing, 26
Photography icon, 132
photos
abstract painting from, 222
adding color to, 215
antique look, 226
apps for taking, 132–141
area in focus, 208
art from, 12
automatically taking three, 140
black and white, 168, 190
blackening shadows, 222
black vignetting around, 159
bleached-out Polaroid colors, 187
blowing highlights, 192, 222
blurring, 168, 202
borders, 157–163, 168

Camera Roll, 177, 180
changing color to gray or gray to color, 214
cinematic look, 191
color fading, 182
compelling effects, 46
consecutive order, 34
contrast, 168, 185
converting to black and white or sepia, 154, 212
copying part of, 199
creation, 200
cropping, 146–156, 167, 221, 230
darkening, 192, 202, 204
deleting, 18, 35, 171
distracting background, 43
editing applications, 12
effects, 168, 180
emailing, 214
exposure, 13, 91, 167
flipping, 154, 167
focus, 36, 38
folders, 18
framing, 55–58, 157–163
full size, 34
Gaussian blur, 112
glowing black-and-white, 184
hazy, 46
image size, 7, 8
inverting, 99
landscape mode, 32–33
layers, 174–177
lens blur, 112
lightening, 202, 204
lighting, 46–48
location, date, and time, 140
looking like sketch, 168
low-resolution, 177
modifying gamma, 221
moveable, 198
noise, 74
number of, 5
on-screen, 7

opening, 200

original sizes, 17

overexposing, 38–39

painting, 70, 198

panning, 217

part sharp and part soft, 36–37, 49

picking up color from area of, 172

pixelization, 7, 8

portrait mode, 32–33

previewing, 135–137, 140, 163, 215, 218

printing, 157

publishing on web, 7

reflections, 159

resizing, 17, 23–24, 144–145

resolution, 6–10, 166, 212, 214

retaking, 200

retro, 188

retro pre-hippie feel, 192

rotating, 148, 151, 154, 167, 221

Rule of Thirds, 55–58

sample, 170

saturation, 167, 185

saving, 135–136, 140, 177, 182, 212–213, 228, 230–231

sending, 180

sepia tones, 168

sharing, 246–251

sharpness, 168, 205

signs, 51–52

silver tint, 193

sketch from, 88

smudging, 199

speaking to take, 138

squaring, 185

straightening, 167

super-expensive equipment and, 11

taken from issue of Life, 186

taking, 32–34, 200, 212, 218, 248

taking away color, 217

tapping to take, 138

thicker and more detailed lines, 222

300 dpi, 7, 8

thumbnails, 34

tonal range of colors, 206

transferring, 17–22

tweaking, 69–70

2-MP sizes, 7

underexposing, 38–39

usage, 200

variations, 228

viewing, 7, 20, 34–35

Viewing mode, 170–172

vignetting, 182

white border, 190

zooming, 35, 173, 217

Photoshop, 54, 98

Bicubic Sharper, 24

proportioning photos, 23

resizing images, 23–24

resolution, 7, 177

Photoshop Bridge, 13

Photoshop Elements, 98

resizing images, 23–24

viewing images at 100-percent resolution, 7

Photoshop Mobile, 54, 88, 98

borders, 160

cropping or rotating images, 154

Photos icon, 5, 34

Photostream, 249

PhotoStudio and sharing photos, 246

Pictures folder, 18

pixelization, 7

Pixel Perfect, 99

PixUp, 246

plants, photographing, 118

PNG files, 23

polarizing filter, 232

Pop effect, 168

Portrait fx filters, 235

portrait mode, 32–33

tall buildings, 90

portraits

animals in action, 76

barrel of distortion, 62

body parts, 80–83

close-up, 62

depth, 72–73

eyes, 57

interactions, 74–75

interesting backgrounds, 71

nondistracting background, 62

positioning groups, 72–73

positioning subject, 66–68

shooting at angle, 77–79

shooting inside vehicle, 63–64

simplifying background, 65–66

sleeping subjects, 68

standard position, 66

subject actions, 62–63

without zooming, 42

positioning

groups, 72–73

subject, 66–68

post-processing and increasing color saturation, 98

previewing photos, 135–137, 140, 163, 218

printing

photos, 157

resolution, 24

ProCamera

Anti-Shake Camera icon, 134–135

Auto Save, 135–136

Full-Res-Zoom, 136

Gear icon, 134

images taken without digital zoom, 137

Pro Grid, 136

setting screen, 134

steady-shot feature, 133

timer, 135

Timer Camera icon, 134

zooming images, 134

ProCamera Basic, 133–136

Pro-Mist filter, 232

PS Mobile, 166–168

R

Rainbow effect, 168

reflections, 116–117, 159

reflective light, 116–117

refocusing camera, 86

repeating geometrical shapes, 52

Resizer, 17, 145

resizing

layer styles, 24

photos, 17, 144–145

resolution, 166

FX PhotoStudio, 218–219

increasing, 177

iPhone 3G and iPhone 3GS, 10

lowering, 74

night photography, 126

PhotoForge, 196

Photo fx, 228

photos, 6–10, 214

printing, 24

saving photos, 212, 219

sharpness, 7

websites, 24

zoomed pictures, 136

retaking pictures, 200, 218

retro photos, 188

RGB color space, 203

rotating images, 148, 151, 154, 167, 221

Rule of Thirds, 51, 55–58

cropping photos, 155

exact placement of shot, 57

eyes, 57

focal point, 106

landscapes, 100

on-screen grid, 136

shooting at angle, 77

subjects, 66

S

sample images, 170

saturation

> brushes, 179

> decreasing, 167

> increasing, 98, 167, 185

> modifying, 207

Saturation option, 167

scenes, worm's-eye view, 111

Scissors

> converting images to black and white or sepia, 154

> cropping photos, 150–152

> placing image inside fixed rectangle, 152

> rotating images, 151

screen

> grids to overlay on, 138

> tapping, 36, 38–39

Search icon, 131

sensor, 10

sepia tones, 168

shade

> best spot to take photo, 118

> lighting, 46–48

shadows

> blackening, 222

> flowers, 87

> lightening, 226

sharing photos

> Flickr, 247–249

> Photobucket, 250–251

Sharpen, 202

sharpness

> close up, 39

> full resolution, 7

> holding camera for, 40

> images, 168, 205

> iPhone 3GS, 15

> lighting for, 46–48

> night photography, 126

> part of photo only, 37

> still lifes, 107

shooting

> at an angle, 77–79

> person inside vehicle, 63–64

shutter

> motion blur, 80

> releasing, 33

> speeds, 13, 15, 115

shutter release timer, 140

shutting down iPhone, 5

signs, good photographs of, 51–52

Silver filter, 193

silver tint, 193

Simple Resize, 144

simplifying background, 65–66

Simulated HDR, 206

sketches, turning photos into, 88

sky, overexposing, 38, 91

sleeping subjects, 68

Sleep mode, 5

Slide to Unlock message, 4–5

smudging images, 199

Soft Black & White effect, 168

speaking to take pictures, 138

special effects, 46

sporting theme, 71

standard portrait position, 66

still lifes, 52–53, 107

street photography, 48, 109–111

subjects

> actions in portrait, 62–63

> directly under light, 121

> distracting background, 42

> ghosts as, 106

> interacting, 74–75

> positioning, 66–68, 72–73

> Rule of Thirds, 66

> shooting inside vehicle, 63–64

> sleeping, 68

> sun at angle, 119

sunlight, 118–119

sunrise or sunset, 105–106

Sunset Boulevard, 62
surface reflections, 116–117
surroundings, color splashing, 69–70
Swanson, Gloria, 62
synching iPhone, 24–25

T

tap focus, 13, 36, 38–39, 49, 103
35mm Nikon camera, 11
300 dpi photos, 7-8
3-MP images
 300 dpi, 8
 size, 8
thumbnails, 34
Tiffen, 232
TiltShift, 112
timer and shutter release, 140
Tobacco color, 240
tool shed colors, 50–51
touch-screen focus, 5, 38
trails from cars, 125
transferring photos
 from computer to iPhone, 21–22
 Macintosh, 17–18
 Windows, 19–21
tropical lights, 46
tweaking photos, 69–70
Twitxr, 246
2-MP photos, 7

U

underexposing images, 38–39
unloading applications, 12
unlocking iPhone, 4–5
Unsharpen Mask, 205

Update All button, **130**
Updates icon, 130
updating apps, 130–131

V

vehicles, photographing people inside, 63–64
Vibrance, 202
Vibrant effect, 168
Viewing mode, 170–172
viewing photos, 34–35
Vignette Blur effect, 168
vignetting, 182
 all-white backgrounds, 65–66

W

Warm Vintage effect, 168
weather, 104
websites
 resolution, 24
 uploading JPEGs, 23
White Glow effect, 168
Wild fx filters, 233–234
window displays and still lifes, 107
Windows, 13, 19–21
Windows Photo Gallery, 20
worm's-eye view, 59, 111

Z

zooming
 Color mode, 217
 objects, 48, 138
 photos, 35, 173, 217
 saving photos at full resolution, 136
zoom lens, 42–43, 97